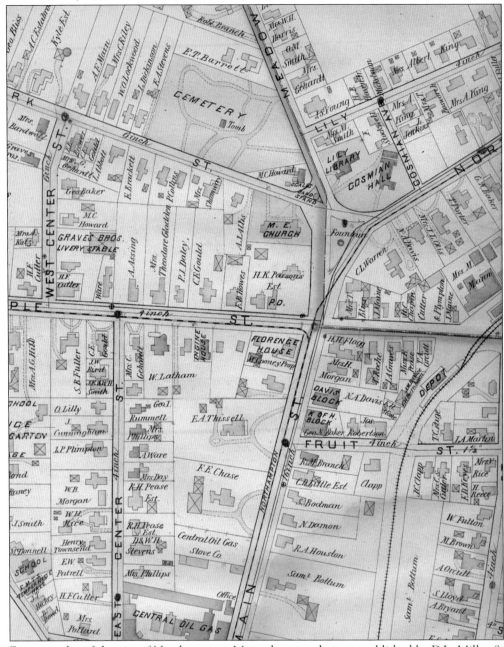

From an atlas of the city of Northampton, Massachusetts, that was published by D.L. Miller & Company, this map shows the center of the village of Florence, Massachusetts, in 1895. (Courtesy of the Florence History Museum.)

ON THE COVER: The Miss Florence Diner is seen here in April 1966. (Photograph by Rodney Kunath.)

Jason A. Clark and Craig P. Della Penna

Copyright © 2013 by Jason A. Clark and Craig P. Della Penna
ISBN 978-0-7385-9841-3

Published by Arcadia Publishing
Charleston, South Carolina

Printed in the United States of America

Library of Congress Control Number: 2012949467

For all general information, please contact Arcadia Publishing:
Telephone 843-853-2070
Fax 843-853-0044
E-mail sales@arcadiapublishing.com
For customer service and orders:
Toll-Free 1-888-313-2665

Visit us on the Internet at www.arcadiapublishing.com

This book is dedicated to the members, both past and present, of the Florence Civic & Business Association and especially to Cary Alan Clark and Michael Patrick Flynn. Over the years, as they laughed about their political differences, their friendship, vision, humor, and hard work reinspired our organization and reminded us of the importance of volunteering within our community.

*In loving memory of
Cary Alan Clark
1955–2012*

Contents

Foreword		6
Acknowledgments		7
Introduction		8
1.	A Walk Down Main Street	9
2.	Merchants, Industries, and Iconic Structures	31
3.	The Howes Brothers' View of Florence	49
4.	Transportation and Street Views	59
5.	Above It All	71
6.	Along the Mill River	83
7.	Recreational Places and Events	93
8.	Frank Newhall Look Memorial Park	105
9.	Paintings and Postcards	117
About the Organization		127

Foreword

In 1894, Charles A. Sheffeld published *The History of Florence*. It was the first book depicting the life, business, and happenings of our village, tracing history from the time of the Nonotuck Indians and the early settling years to the rise of the silk industry and the Nonotuck Silk Company, the Free Congregational Society, and the great Mill River flood. In 1985, the book committee of the Florence Civic & Business Association published a second history of our village, covering the years of 1895 to 1985 and providing us a glimpse of the influential businesses and personalities of the times.

This presentation of the history of Florence provides a look into the generations of merchants, industries, and organizations that have come to shape the life of our community, and the way that the Florence Civic & Business Association itself has grown with the participation of people of all ages for the benefit of our village and its residents. The Florence History Museum, Look Memorial Park, the *Daily Hampshire Gazette*, Forbes Library, Historic Northampton, and the members of the Florence Civic & Business Association have provided some of their best historical images that capture life in our village of Florence, Massachusetts.

—Gordon Murphy

Acknowledgments

Thank you to David Clark for your substantial contributions, especially over the last several months of this project. You will always be equally considered an author of this book, and I am extremely grateful for the time and effort you spent working with me and for your guidance in helping me get through a very difficult year.

Thank you to our friends and our loving families for your patience and support, especially Melody A. Clark, Emma Cecile Clark, Kathy Della Penna, Mary A. Clark, Aaron Clark, Amie Clark, Ava Clark, Steve Holloway, Jennifer Holloway, Alexandra Holloway, Ryann Holloway, Kathy Clark, Gay Kendrew, Al M. Turtlee, Don Wade, Kathy Gagnon, Gordon Stanley "Bucky" Murphy, Nancy Murphy, Michael P. Flynn, Ned Gray, Richard Finck, Rodney Kunath, Mitch Alexander, Mary Rita Tremblay, Enace Lococo, Judith Lococo, Richard Cooper, Gloria H. Tuperkeizsis, David E. West, Chris Powers, Greg Malinowski, Bill Hogan III, Bob "Cash" Wade, and John Zantouliadis.

Thank you to the Florence Civic & Business Association, the Florence Mercantile, Historic Northampton, Look Memorial Park, the *Daily Hampshire Gazette*, Forbes Library, the City of Northampton, Florence Casket Company, and Pivot Media.

Unless otherwise noted, the photographs in this volume appear courtesy of the Florence History Museum, located at the Florence Civic Center.

A book like this requires the use of many written histories, stories, narratives, articles, and books, and we wish to acknowledge the following: *History of Florence, Massachusetts* by Charles Sheffeld, the personal notes and articles of Walter and Lottie Corbin, *Florence: A Small Village on the Mill River* by Alice Manning, *Florence, Massachusetts History, 1895–1985*, edited by the Florence Civic & Business Association, "The History of Industries in Florence" by Gretchen Good, and the historical documents and records of Jim Parsons and the City of Northampton.

INTRODUCTION

In 1681, four men were granted permission to construct a sawmill along the banks of the Mill River in what was then known as Broughton's Meadow. The sawmill and surrounding land changed hands several times throughout the early 18th century. In 1733, the first bridge over the Mill River was constructed just above the sawmill. In 1778, Joseph Warner built his home on the west side of North Main Street, and not long after, his father, Daniel built a house nearby on Bear Hill. Both are believed to be the first homes built in Broughton's Meadow. In 1798, Gaius Burt built a third home (now known as the Ross Farm) on Meadow Street.

When 120 years had passed since the approval of the sawmill, there were still only a handful of people living in Broughton's Meadow. By 1820, the population had grown to about 50 people, and the Industrial Revolution was about to sweep through and transform Broughton's Meadow into a manufacturing village.

The next few decades saw the rise of the local silk industry. The Northampton Association for Education and Industry was established in 1842 and would be directed by such men as Samuel Hill, George Benson, and Joseph Conant. The history of Florence would forever be affected by these men's business successes, philosophical ideas, and generous contributions to the community.

In 1852, local residents unanimously voted to name their village Florence. In December of that year, despite opposition from the postmaster of Northampton, Florence was granted its own post office.

By 1867, Florence had over 2,000 residents, and its companies were manufacturing products that were being shipped around the world. The solid foundation that had been set by early residents paved the way for a new generation of companies to set the standard of local business throughout the 20th century.

Thomas Orcutt began his hardware business in 1872 in the building occupied by Florence Hardware. The Florence Casket Company and Florence Savings Bank were both established in 1873. In 1883, John W. Bird purchased a news store that eventually became the neighborhood corner store now known as "Bird's," located in the Parsons Block. In 1908, Frederick Rogers opened a business repairing horse harnesses and later sold hardware, sporting goods, and bicycles.

In 1928, Fannie Look donated over 100 acres of land to the City of Northampton for the establishment a park in honor of her late husband, Frank Newhall Look. Over the years, Florence residents' giving nature and tolerance of different ideas and beliefs have led to the establishment of many churches and organizations throughout the village.

In 1946, the Florence Civic & Business Association was founded with many of the same principles and ideas of its earliest residents. The association continues to help promote the local businesses and encourages the residents of Florence to contribute to the community in any way they can. The photographs herein provide a look at some of the early residents, organizations, and structures, along with the many changes throughout the village that have helped to make Florence what is it today.

One
A Walk Down Main Street

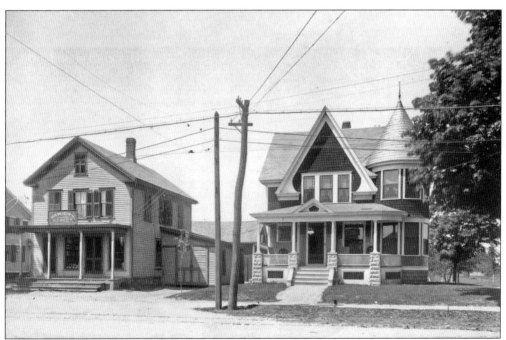

Upon entering the village of Florence, the first house one comes across on Main Street is an attractive Victorian structure that was built in 1905. Originally owned by Herbert S. Richards, it is located at 1 Main Street. Richards ran the grocery store and soda shop that was located at 3 Main Street, seen on the left side of this photograph. That building was later demolished and replaced by the building now occupied by the F.J. Rogers Bike Shop, which has been in operation for over a century. (Courtesy of Historic Northampton.)

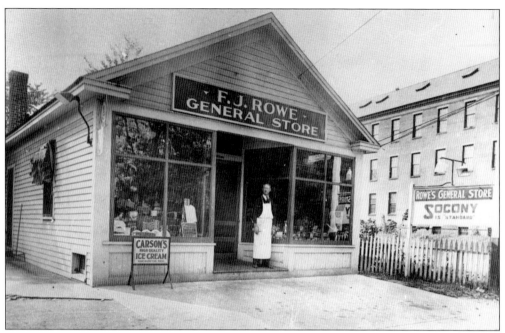

Frank Rowe's General Store at 6 Main Street sold gasoline, groceries, and home items during the 1930s and 1940s. Neighborhood children especially appreciated the Hoodsie Cups, an ice-cream treat in a cup that featured a souvenir photograph. The building was demolished in the 1980s, and an office building stands there today. (Courtesy of the *Daily Hampshire Gazette*.)

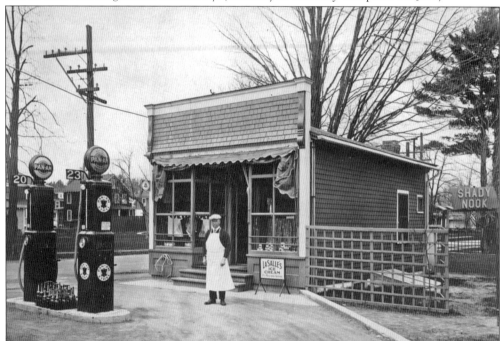

This 1918 photograph shows Chancey Frayer's General Store on the corner of Main and Chestnut Streets. Like his eventual neighbor Frank Rowe, Frayer sold gasoline, groceries, and, for the kids, a local brand of Lasalle's Ice Cream. A barbershop now occupies this building at 17 Main Street.

The brick buildings of the former Florence Machine Company have dominated Main Street from the 1870s until today. Over the years, the company made sewing machines, oil stoves, gas stoves, and many other products. (Courtesy of Historic Northampton.)

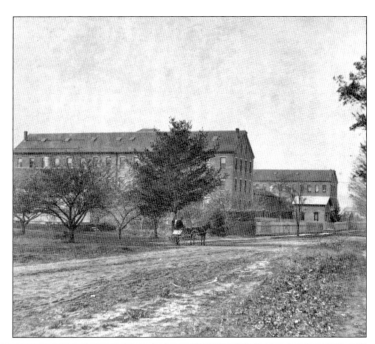

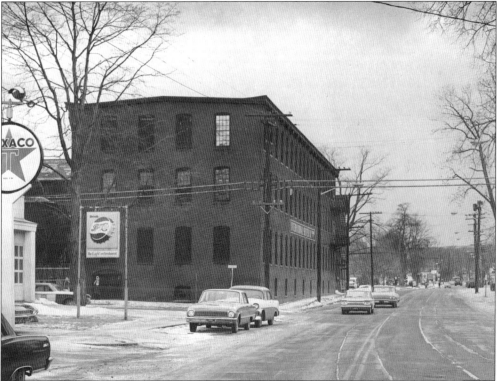

This large brick structure was once located at 22 Main Street. It was a major building in the Florence Sewing Machine Company and later in the International Silver Company. It was so large that it darkened that area of Main Street. The building was demolished in the late 1960s, and the land is now occupied by a gas station on the corner of Chestnut Street and Main Street.

This is 10 Main Street as viewed from Coopers Corner in 1970. The building was occupied by the Pioneer Valley Soda Company, Calduwood Enterprises, and the Florence Publishing Company. It has recently been returned to its earlier historical appearance and is now occupied by several medical and professional offices. (Courtesy of the Forbes Library.)

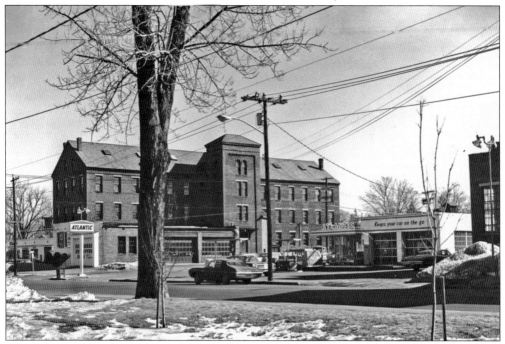

The Atlantic gas station is now a Citgo station operated by the family of Robert Gougeon. This lot was once part of the Florence Machine Company and, later, the International Silver Company. (Courtesy of the Forbes Library.)

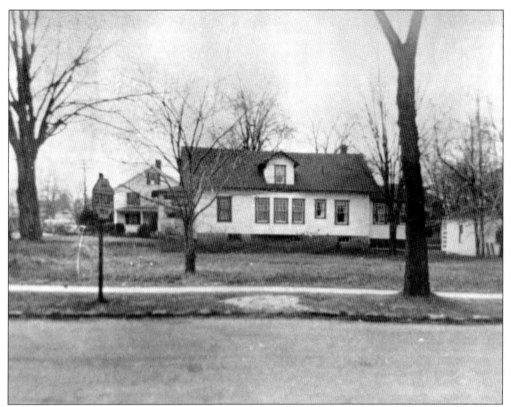

The Cooper homestead was located at 35 Main Street. The house was moved to 188 North Elm Street just prior to the expansion of the Coopers' grocery store in 1985. The spot on which it stood is now the parking lot at the main entrance of Coopers Corner. (Courtesy of Rich Cooper.)

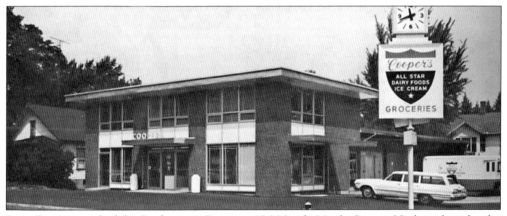

Russ Cooper worked for Bridgman's Dairy at 126 North Maple Street. He later bought the business and moved it to Coopers Corner in 1938. During the early 1950s, Cooper operated a small luncheonette in front of his dairy business. After a fire destroyed much of the dairy operation in 1964, the business was converted to a full retail store in 1967. It remains in the Cooper family today.

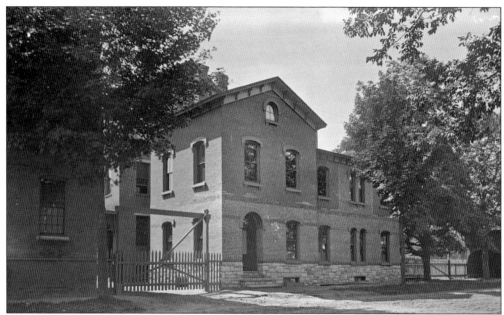

The structure at 40 Main Street was the front office building of the Florence Machine Company. The International Silver Company purchased the buildings in the 1920s, and most were closed with its decline. This one remained open, though, and temporarily housed the Cooper's Dairy offices in the 1960s. It still stands today, having been occupied by many local businesses over the years. (Courtesy of the Forbes Library.)

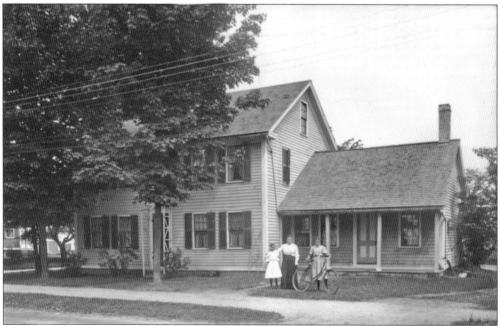

This colonial house, originally owned by Samuel Bottum, once stood at 41 Main Street. Early maps indicate that this house was surrounded by a large open yard. The lot was filled in with a gas station to the left, and Wilder Place on the right side. In time, the house was razed to make way for an office building. (Courtesy of Historic Northampton.)

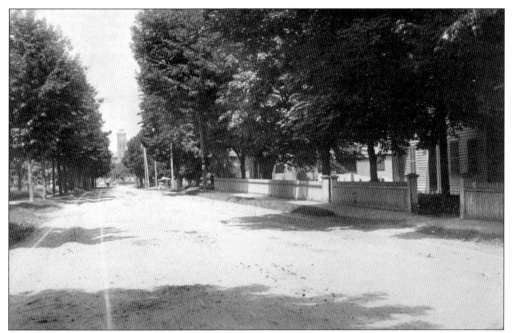

This 1890s westward view of Main Street is notable because of the trolley track right-of-way in the dirt street. The street was lined with large shade trees along both sides, and in the distance, the Cosmian Hall tower rises above the tree line.

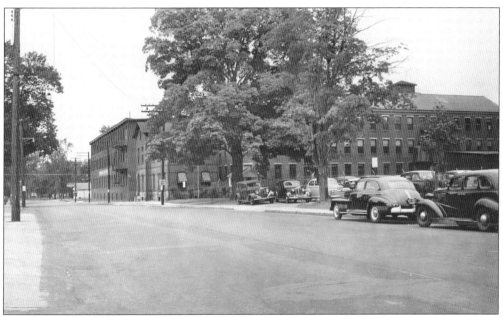

A 1940s photograph looks eastward on Main Street, toward 22 Main Street and 40 Main Street. Recently restored, 40 Main Street is now home to many local businesses, including the Tranquility Day Spa and various medical and professional offices.

Located at 60 Main Street, this house was built by Frederick Ely in 1906. It was moved by the Florence Civic & Business Association in August 1966 to its current location at 90 Park Street, where it now serves the village as the Florence Civic Center.

The large house to the left was located at 54 Main Street, the current site of Friendly's Restaurant. The building was once home to Frederick E. Chase, a chief of the Florence Fire Department. Pioneer National Bank began construction on its new branch at 60 Main Street in 1966. It opened its doors the following year and operated at this location until it was converted into a family restaurant in 1991.

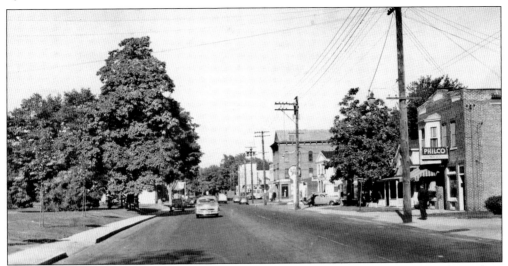

This postcard image from the 1950s looks west on Main Street. The building to the right is where Albert Meisse operated his television repair shop from the 1950s into the 1980s. Later it became Florence Video, a variety store, and, more recently, a pizzeria. Farther up the street is Maroney's Texaco Station, followed by the Knights of Honor Block and the Davis Block.

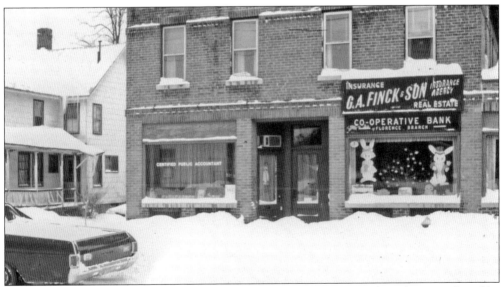

The brick structure at 63 Main Street was built by Edwin C. Addis and was later purchased by Gustave A. Finck in 1940. During the 1970s, G.A. Finck & Son Insurance Agency shared the space with the Northampton Cooperative Bank for a collection office. (Courtesy of Richard Finck.)

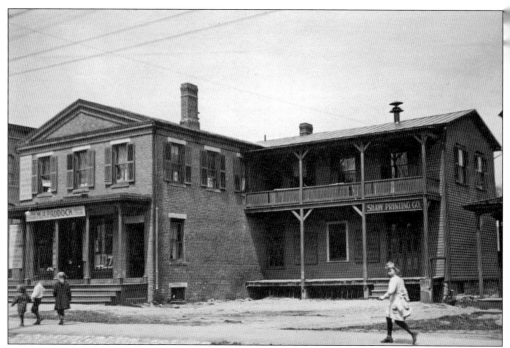

Once located at the corner of Main and Fruit Streets, this building was constructed by the Florence Mercantile Association in 1867. The association disbanded, and the building was sold to R.M. Branch in 1876. From then on, it was known as Branch's Block and housed such businesses as Schaeders Photography Studio, Shaw's Printing, and a meat market. In about 1946, John Maroney bought the building and ran a gas station.

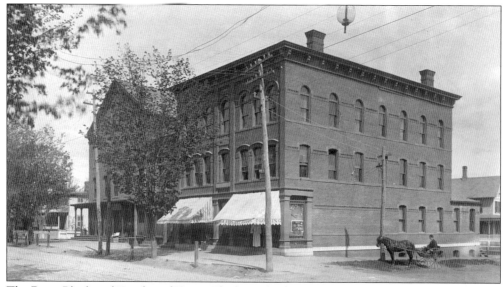

The Davis Block and Knights of Honor Block met both vital commercial and community needs for many years. The Knight of Honor building, erected in 1885, had a large meeting place in the upper floor, with retail space on the street level. The block was demolished in 1977 and is now the site of Florence Savings Bank on the corner of Main and Keyes Streets.

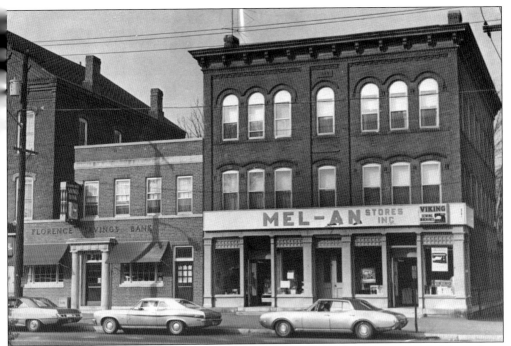

Mel-An Stores, Inc., specialized in Viking Sewing Machines and other sewing goods. Throughout the 1950s and 1960s, Robert C. Callahan and his wife, Edna, ran a five-and-dime store on this corner. The marker stones visible in the middle of the upper two stories of the building are both displayed behind the Cosmian Bell at the Florence Civic Center (Courtesy of the *Daily Hampshire Gazette*.)

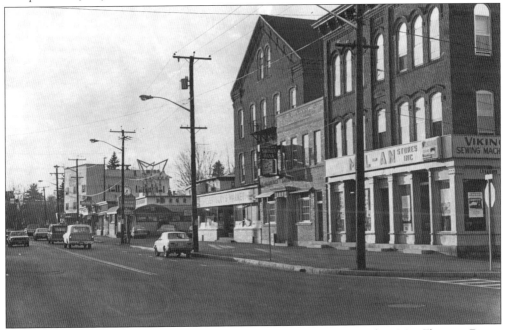

This view looking west from Keyes Street in 1977 shows Everybody's Market, Miss Florence Diner, and the Goodwin Block. (Courtesy of the *Daily Hampshire Gazette*.)

Three houses were razed to make way for the medical offices at 70 Main Street. The white house in the middle, located at 64 Main Street, was built around 1895. The house to the right was built in 1831 and was once known as the Arthur Sowerby house. It was later owned by the Pruzynski family, and Mrs. Pruzynski's pet cow was often seen grazing on the front lawn in the 1930s.

The third house razed for the medical offices was located at 86 Main Street. If it were still standing today, it would be located just to the left of Murduff's Jewelry.

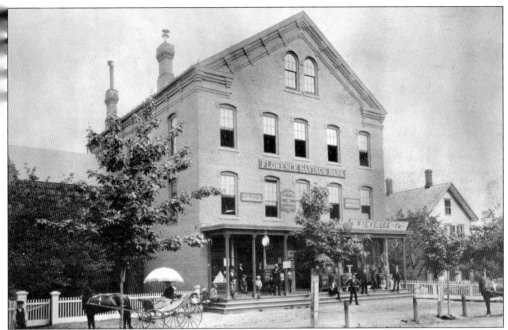

The Davis Block was built in 1870 by Nelson Davis, who operated his drugstore on the street level. Henry Bond practiced law in an office on the second floor where, in 1873, a community bank was established. It was originally called the Working Man's Bank but very quickly became the Florence Savings Bank. It operated out of Bond's office until 1891, when it moved next door to its own building.

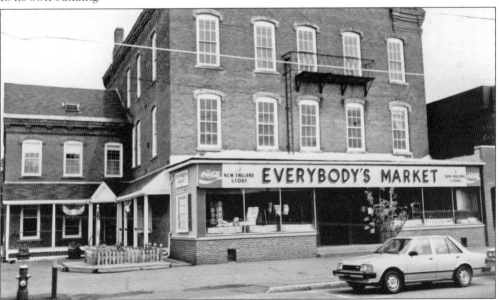

Everybody's Market was established in 1933 by Charles Selvecki, and the Jasinski family continued to operate their grandfather's market into the early 1990s. The left side of the building was occupied by the Murphy's Realtors at the time of this photograph. Surprisingly, the upstairs of the main building remained virtually unused for many years until being converted into condominiums in 2005.

The Latham Lodging House was located at 92 Main Street until it was razed in the mid-1970s. A log cabin was constructed in its place and served as Yesterday's Tavern, operated by John Sparko. In 1985, the cabin was moved to Shutesbury for use as a Christian camp. Murduff's Jewelry occupies the two-story, brick structure that is now located on this lot. (Courtesy of the *Daily Hampshire Gazette*.)

This was the home of John Whitherell, located at 99 Main Street. In the 1920s, Ed Slattery moved his lunch cart to a spot on the lawn and operated his lunch business there for a few years before moving across the street to 92 Main Street. Maurice Alexander purchased the Whitherell home in 1941 and placed his own portable diner on the front lawn. The building still stands today, now occupied by Silk City Taproom.

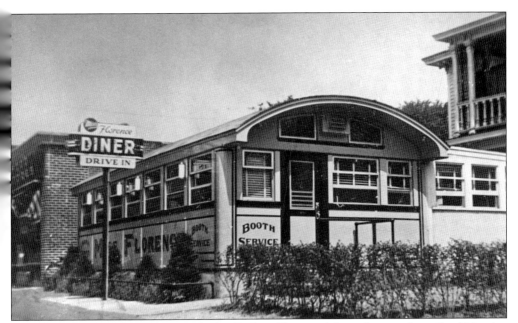

The Miss Florence Diner was named after Pauline Florence Montechevicz, the wife of Maurice Alexander. Since the Alexanders established the diner, it has become an iconic dining experience for thousands of visitors to the western Massachusetts area. The building itself has evolved over time, and now the "Miss Flo," as it is called, is listed in the National Register of Historic Places. (Courtesy of Mitch Alexander.)

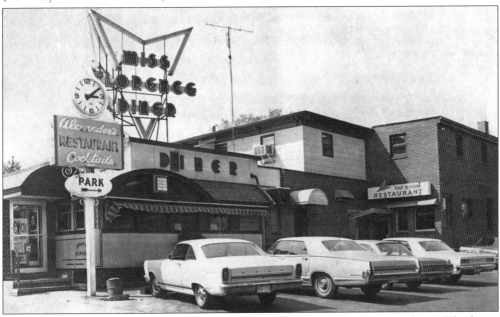

This 1965 view shows the Miss Florence Diner with her triangular neon roof sign. The large, circular clock on the front identification and parking sign helped keep everyone in Florence on time. With the success of the diner business, the family eventually moved from their quarters in the old Witherell house and expanded the restaurant back into that building. (Courtesy of Mitch Alexander.)

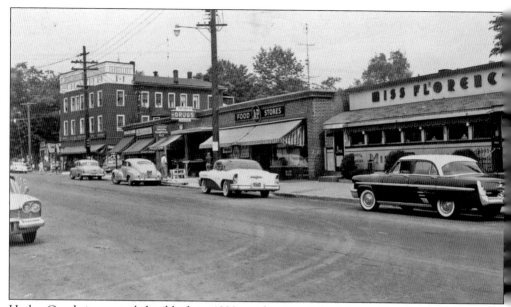

Harley Goodwin erected this block in 1923 on the site of the historic Paul Strong Tavern. At the time of this photograph, F.J. Rogers Bike Shop, Murduffs Jewelry, and Tremblay Drug Store were located in the block. Also seen is George "Jerdy" Purcell's tavern, which was locally known as "The Moscow" and was a favorite stop for many years.

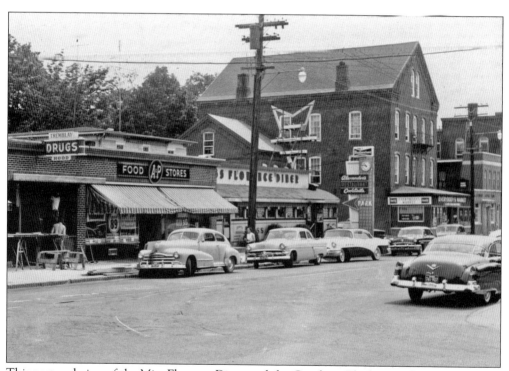

This postcard view of the Miss Florence Diner and the Goodwin Block was taken in the 1950s, when the A&P Food Store occupied the space that is now the Florence Post Office.

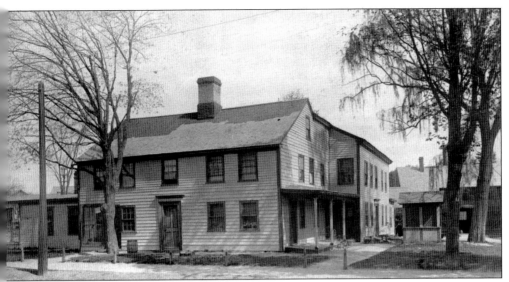

In 1809, Oliver Warner built a tavern on the corner of Main and North Maple Streets. Its location on the main travel route between Boston and Albany helped make it a key stagecoach stopping point. Paul Strong purchased the inn and tavern, and it continued to flourish until 1845, when a newly established rail line to Albany led to a decline in tavern business.

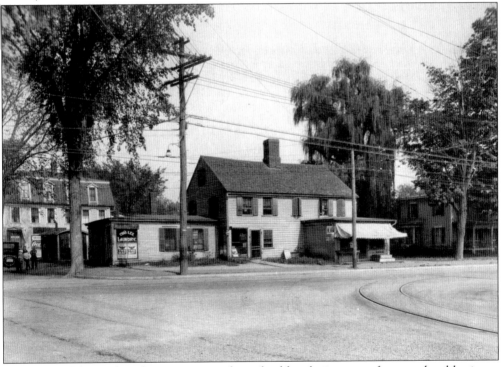

The tavern did not close, however; it merely evolved by placing more focus on local business. The Charlie Lee Laundry occupied the left side of the building, and the tavern expanded the entertainment and beverage aspects of its operation. Notice the shiny rails set in the roadway. These carried the horse-drawn trolleys, affectionately referred to as "horse cars," that traveled between Northampton and Florence.

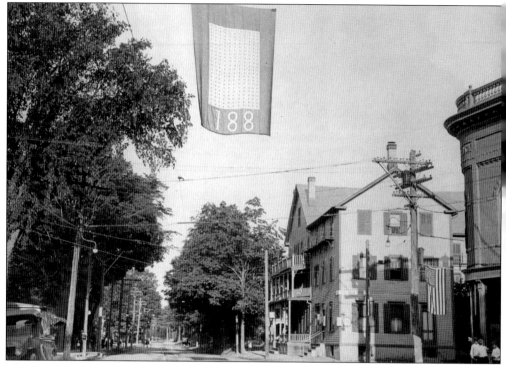

The Florence Hotel was built by Joel Abercrombie in the 1850s at the corner of Main and Maple Streets. James Stone acquired the hotel in 1870 and added a third floor. The building was demolished after a major fire in 1921. In this image, a flag is seen hanging above the street as part of a commemoration ceremony honoring the 188 residents from Florence that served in World War I.

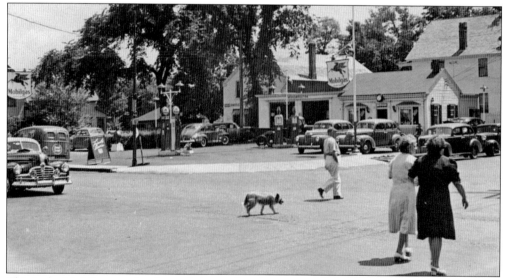

This is the Mobil gas station formerly located at the corner of Maple and Main Streets, pictured in the 1940s. At the time of this photograph, John Breguett owned the station. It later passed to the Morrow brothers, who ran it for many years. On the left side of this image is Nancy Murphy, driving her Desoto touring car.

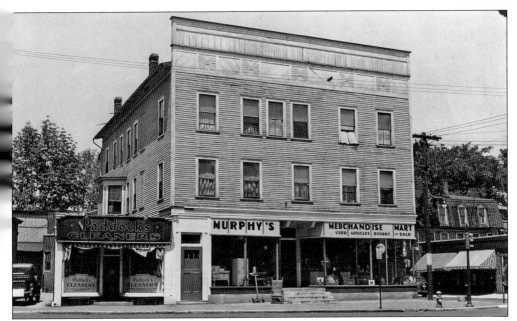

Built in 1889 by Clara Maine, this block replaced a smaller structure on this lot. Many successful businesses have operated at this location, including the Murphy's Merchandise Mart, shown in this 1946 photograph. The small building to the left was used by Keyes Florists and later used as a barbershop, bakery, and a tailoring business owned by Stanley Paddock. It is now used a mail room for the residential units on the upper floors.

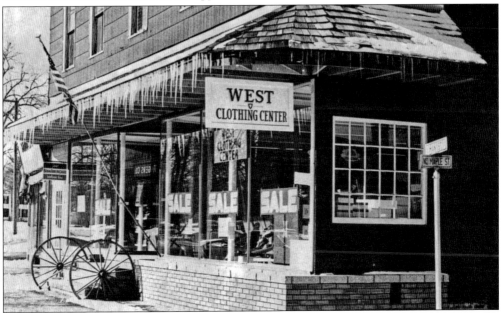

David West and Kevin Cox offered an extensive selection of clothing for the entire family at the West Clothing Center. Originally located at 11 North Maple Street, the store was moved to the Maine Building in 1969. In 1975, Jim Sadler was commissioned to paint the familiar mural, titled *Go West*, which covered the facade of the building. Many residents will always remember this as the "Go West Block." (Courtesy of David West.)

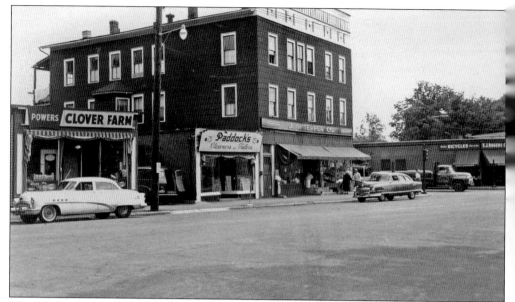

Mary G. Powers managed the Powers Store for many years at 9 North Main Street. This space is now occupied by Leather and Lace Beauty Salon. Also seen in this picture are Stanley Paddock's tailoring business and J.A. Tepper & Co.

In 1880, this building at 9 North Main Street was built for George Maine, the brother of Julius Maine. John Powers ran the J.T. Powers store in the lower level of this house during the early 1900s. Years later, an addition was constructed on the right side of the building.

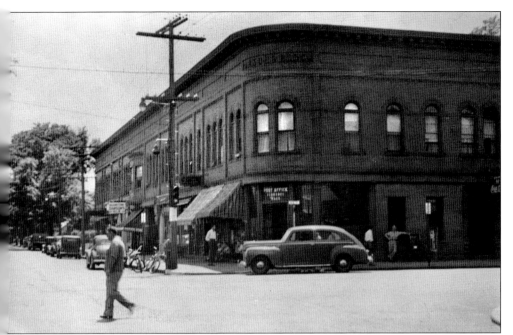

Charles O. Parsons built the first section of the Parsons Block in 1901. The second section was built along Maple Street in 1904, and the two sections were connected on the second floor with a covered alleyway at ground level that ran through the area of the Florence Center Launderette at 86 Maple Street. The corner of this building was once the Florence Post Office and now occupied by Bird's store.

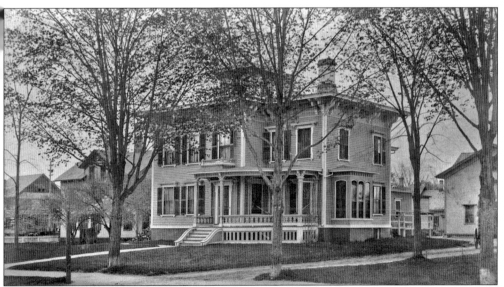

The Parsons House was located at 12 Meadow Street and was situated in a very large lot that extended over to the corner of Main and Maple Streets. In 1901, Charles O. Parsons built the Parsons commercial block on that same corner. The house was later demolished to provide parking space in the back of the Parsons Block.

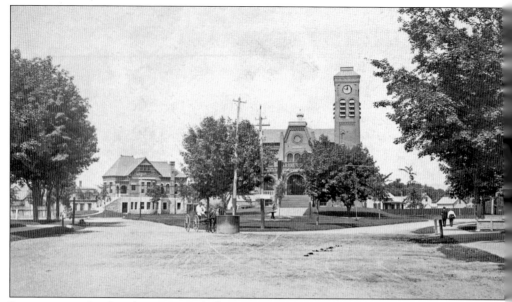

It was no mistake that the imposing bell tower of the Cosmian Hall was visible as soon as one entered the village from Northampton. A well-planned village center led visitors up Main Street, directly to this picturesque park, which was the subject of many postcards in the early 1900s.

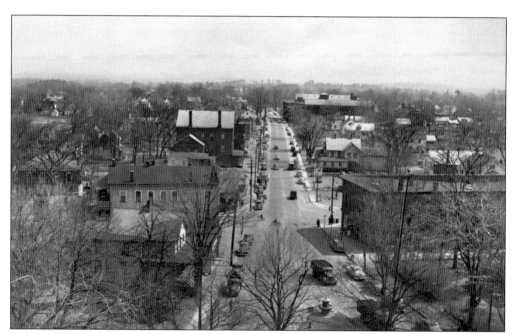

A look back over Main Street from the Cosmian Hall tower in the 1940s reveals familiar buildings like the Parsons Block, the Davis Block, and even the Maine Building that still exist today. Many of the residential buildings however, especially along the south side of Main Street, have given way to the commercial expansion within the center of Florence over the last 50 years.

Two
Merchants, Industries, and Iconic Structures

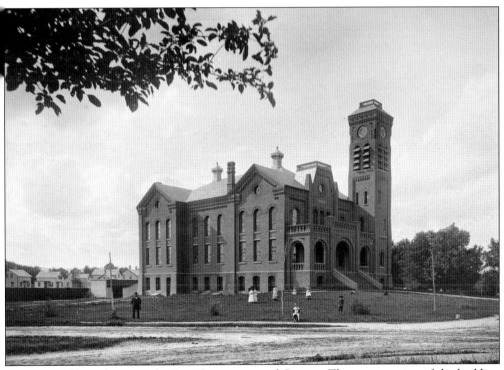

Cosmian Hall was home to the Free Congregational Society. The construction of the building cost $40,000, largely paid for by Samuel L. Hill and Arthur T. Lilly, and was completed in 1874. The interior of the hall had a large, open theater that accommodated up to 700 people. Above the stage was the inscription "Above All Things, Truth Beareth Away the Victory."

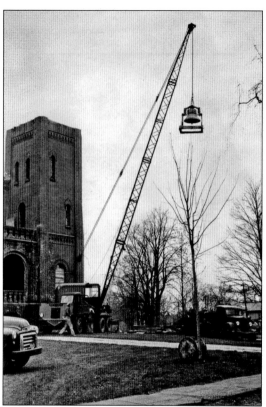

In the 1920s, Cosmian Hall was sold to the Florence Amusement Association, who briefly used it to show silent films. Hill Institute purchased it in 1934 and later transferred ownership to the YMCA in 1946. By that time, the hall was in such disrepair that it was scheduled to be demolished a few years later. The bell was lowered from the tower on April 8, 1948, and moved into storage.

The demolition continued for the next month, and by May 20, not much remained. Once the demolition was complete, the lot was graded over. It remained vacant for the next 20 years, during which time it was often referred to as the "Cosmian Green" and was used for civic functions and ice-skating rinks in the winter.

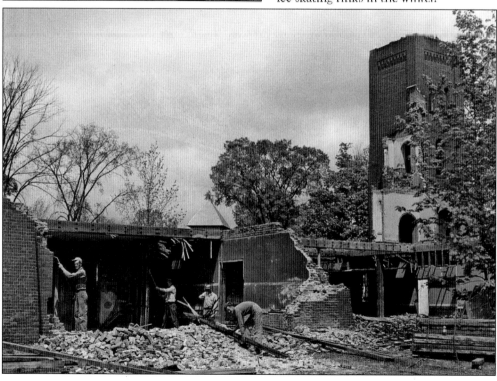

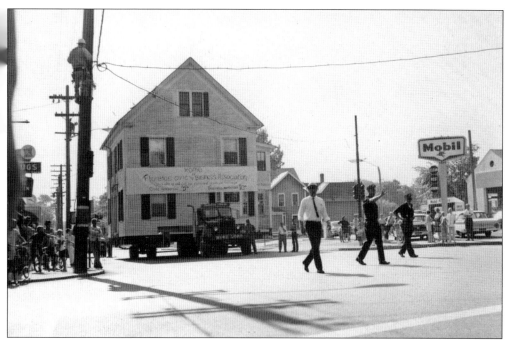

In 1955, the Florence Civic & Business Association purchased the lot known as Cosmian Green. In 1966, the house located at 60 Main Street was donated to the organization by the Pioneer National Bank. Spectators lined both sides of Main Street to watch the house roll by. It was covered with a giant banner (designed by Agnes Shea) soliciting new membership for the organization.

After rolling through the center of Florence, the house was successfully moved into its new location. It was set into position on the foundation, and a new hall was added onto the rear of the building.

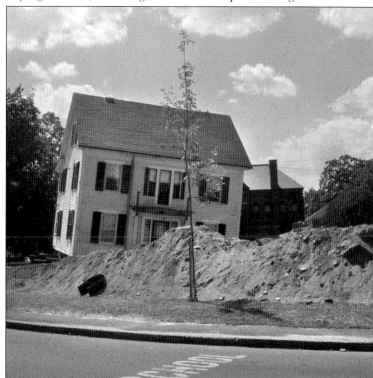

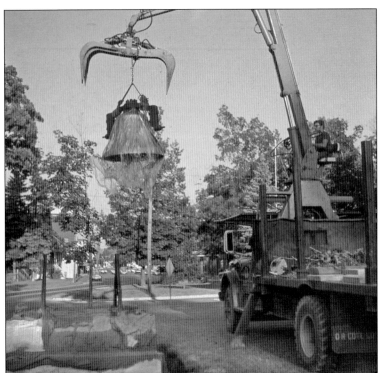

In 1972, almost 25 years after the demolition of Cosmian Hall, the bell from the clock tower was lowered into place on its commemorative red-stone base (positioned at the site of the old bell tower) on the lawn of the civic center.

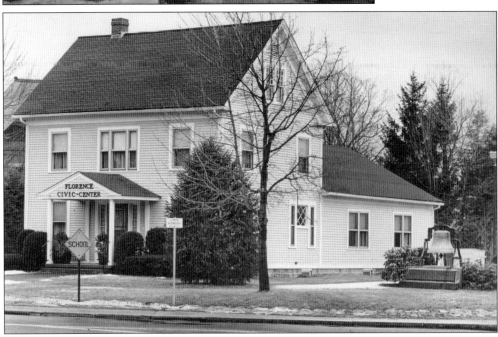

In 1946, the Florence Civic & Business Association was established. The organization has been involved in many community projects throughout the years. In September 1967, they held their first formal meeting in the association's new permanent home. The front of the building is home to the Florence History Museum, which houses local artifacts and ephemera donated by the citizens of Florence over the years.

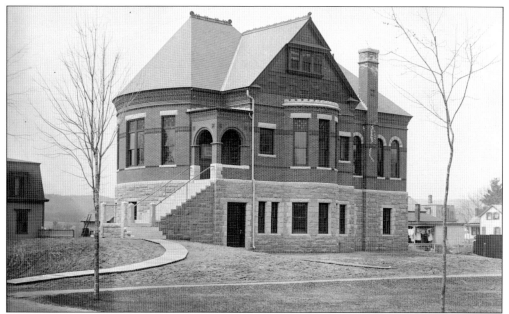

Alfred Lilly gave $12,000 for the construction of a public library in Florence. Designed by C.H. Jones of Springfield, Massachusetts, construction began in 1889 under the direction of contractor Joseph Hebert and mason John Mather. The Lilly Library was completed and dedicated in May 1890. Although the structure was primarily used as the public library in Florence, the lower room served as the Lilly Kindergarten from 1894 until 1938.

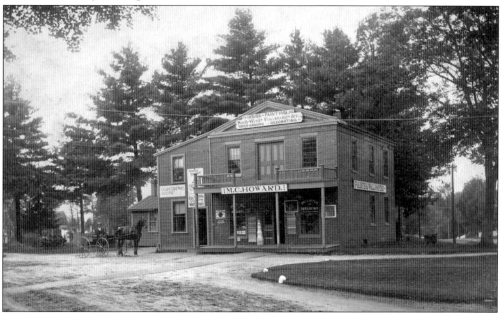

The M.C. Howard store was located at the corner of Meadow and Park Streets. The building was originally the village school, constructed in 1846. In 1863, a new school was erected, and this former schoolhouse was converted into a retail store. In 1889, M.C. Howard purchased the store and began selling household goods. Today, the building is gone, and the War Memorial is located on this land.

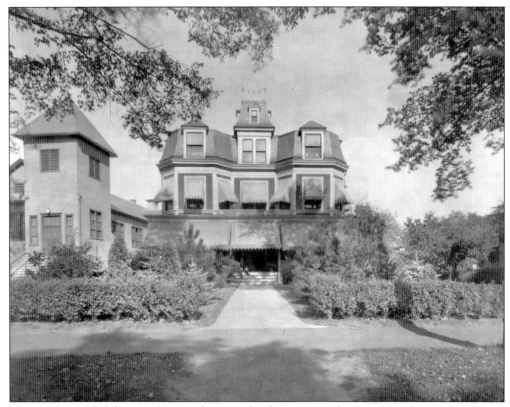

The residence of Nelson A. Davis, who owned a drugstore in the Davis Block on Main Street, was built in 1886. From 1927 until 1941, the house served as a lying-in hospital. In 1951, it became the Florence Home for the Aged; it was later known as the Florence Rest Home.

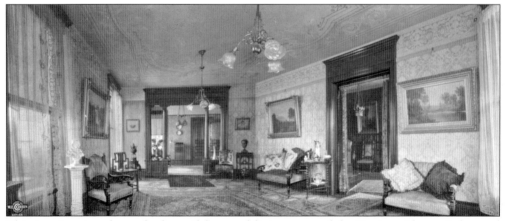

This interior view shows the beautiful central living room of the Davis residence. It boasted period furniture; classic windows; substantial crown moldings; and elegant, yet conservative, light fixtures. The walls were adorned with a wonderful collection of American artwork.

Construction of the Florence Methodist Episcopal Church began in 1873. While the exterior of the building was mostly complete the following year, the interior was not finished until 1884, and the church was officially dedicated in June of that year.

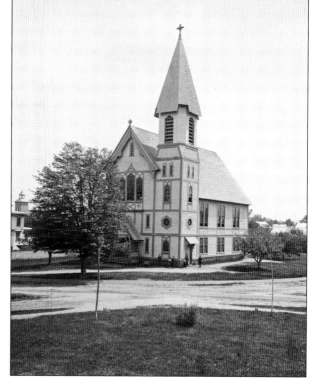

Over the years, the steeple was renovated several times and was eventually removed in 1972. Many of the windows have been covered by siding, but the building still stands today as the home of the Florence Veterans of Foreign Wars. The addition in the back of the church now serves as the bar and lounge area.

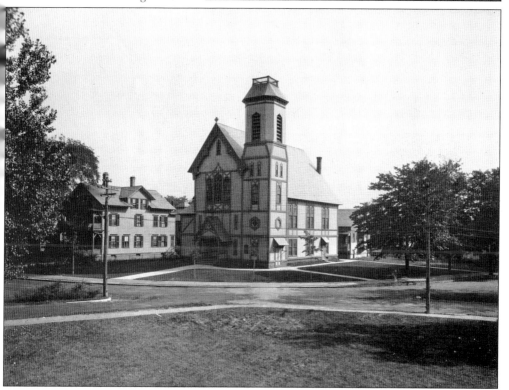

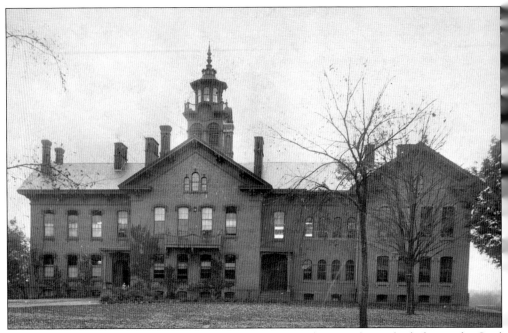

The old Florence Schoolhouse, shown in this A.W. Howes photograph, was built during the Civil War between 1863 and 1865 at a cost of $33,000 (of which Samuel Hill paid $31,000 and the town, $2,000). The building originally consisted of the middle and left side of the building, with a large addition later added onto the right side.

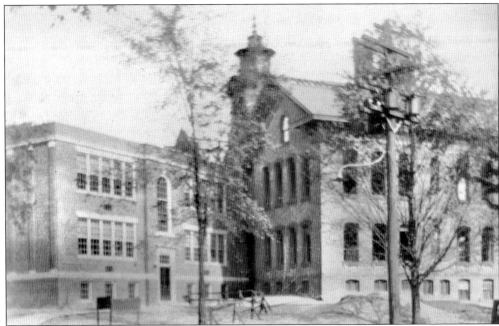

By the 1920s, the old schoolhouse was in a state of disrepair, and it was decided that a more modern schoolhouse was needed in Florence. In 1929, the newer Florence Grammar School was built on the lot directly in front of the old schoolhouse. When construction was complete, the old schoolhouse was demolished to make way for the parking area and playgrounds.

The Florence Congregational Church at 130 Pine Street was built in 1861 at a cost of $4,000. In 1878, an organ was added, and electricity was installed during renovations in 1890. Today, parishioners are still eagerly awaiting the arrival and installation of the clocks within the circles of the steeple, which was originally to have taken place within a few years of the building's completion.

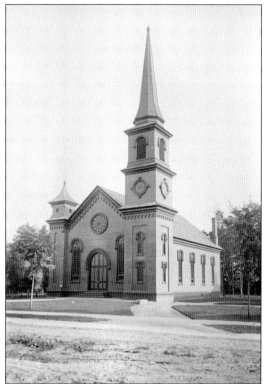

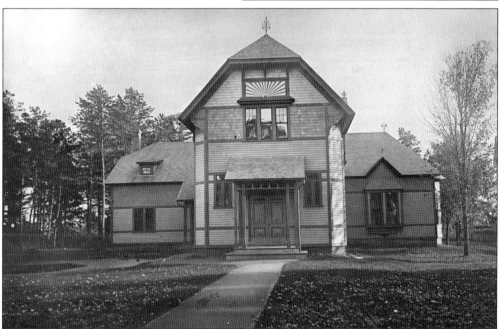

In 1864, a separate chapel was erected for Florence Congregational, and the church was opened up into a large meeting space. A fire destroyed the newer chapel in February 1885, and this structure was built in its place later that year. In 1961, both the church and the chapel underwent further renovations, and the two buildings were connected.

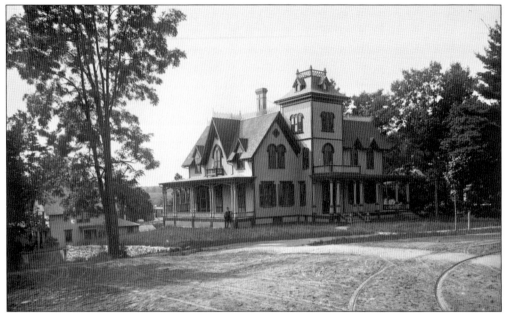

This home was built for A.L. Williston at 98 Pine Street in 1865. The family owned expansive acreage of land along the Mill River, and this home sat on the hill above it. The residence was characterized by a tower to the front, steep roofs, elegant windows, and significant iron detailing throughout. The home still stands, but most of the architectural detail has been removed or obscured by siding.

The Florence Kindergarten was started in the home of Samuel L. Hill and was briefly held in Cosmian Hall during its second year. The kindergarten was such an immediate success that Hill made plans for a permanent structure, and the new building was completed and dedicated in December 1876. Over 135 years later, the Florence Kindergarten is still in operation as the Hill Institute.

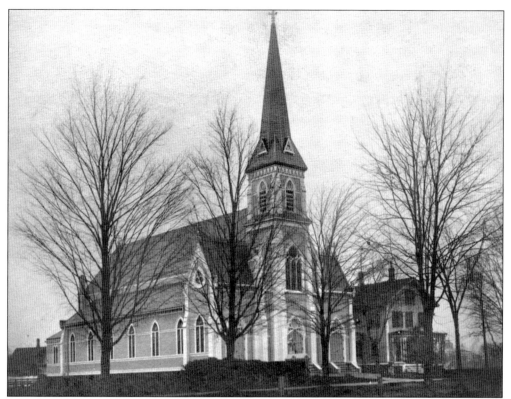

In 1878, Bishop Patrick Thomas O'Reilly sent Fr. Cornelius Foley to Florence to start a Catholic parish. That August, Father Foley bought the Learned House, located on Beacon Street. Sadly, he fell ill, and Fr. Patrick Callery had to take over the work of building the church. Through diligent effort and dedicated fund-raising by faithful parishioners, the church was built in 1880. It still exists as the Chapel of Saint Elizabeth Ann Seton.

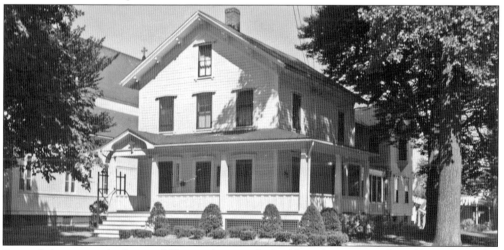

Formerly known as the Learned House, this was the building that was purchased by Father Foley in 1878. Next to it can be seen the church built by Father Foley, Father Callery, and the parish faithful. The house served as the rectory until 1948, when it began functioning as a convent. It was torn down in 1976.

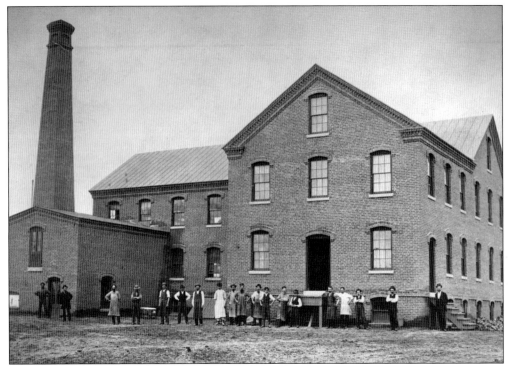

Alfred T. Lilly was the first president of the Florence Furniture Company, which was established in 1873. The company manufactured undertaking supplies and fine-wood and cloth-covered caskets. Now known as the Florence Casket Company, it still operates at the same location and remains one of the leading manufacturers of fine-wood caskets in all of New England.

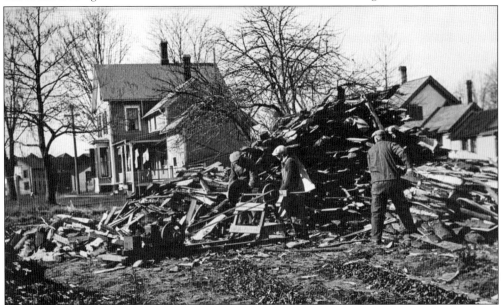

This early-1930s photograph shows three men hard at work, splitting wood to heat the greenhouses for F.D. Keyes. The house in the background, located at 25 Keyes Street, was built about 1873 on the lot between the old railroad and 29 Keyes Street. (Courtesy of Mary Clark.)

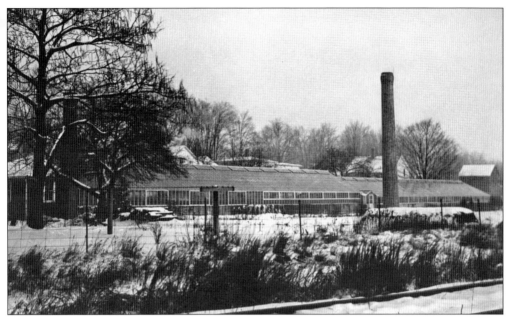

For almost 80 years, the Keyes family ran a successful flower shop in several different locations on Main Street and Maple Street. Fresh-cut and potted flowers were grown in their greenhouses behind the house on 29 Keyes Street. A bike path now runs along the abandoned rail tracks in the foreground, and the Florence Savings Bank parking lot occupies the land near the greenhouses. (Courtesy of Mary Clark.)

Shortly after Keyes Flower Shop closed in the mid-1980s, Mary and Cary Clark purchased the business and renamed it the Florence Village Flower & Gift Shoppe. The flower shop continued to operate at this location until 1993, when it was moved to 5 North Maple Street. (Courtesy of Mary Clark.)

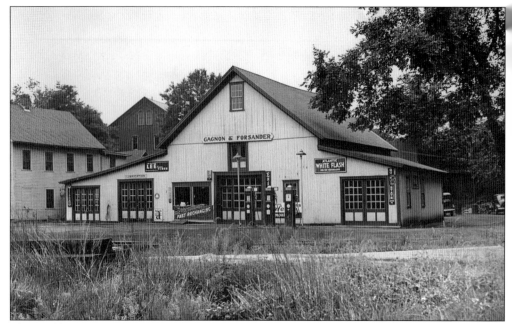

This building, located on Depot Avenue across from the railroad depot, was originally the livery stable owned by C.H. Burnham. As the horse-and-buggy era declined, it was just natural for an automotive service station to take over this space. The Gagnon & Forsander Garage operated here for many years until the building was purchased and demolished to make room for a parking lot.

This mansion, surrounded by 70 acres of farmland and woods, was built by Samuel L. Hill for his daughter Emily in the 1870s. Dr. John Learned married Emily Sheffeld in 1884 and spent much of his life caring for his patients, farming the land, and educating people about good nutrition. The home fell into disrepair during the 1930s and was torn down in 1941. The Forsander Apartments now occupy this land.

Doctor Learned, who had a keen interest in the study of nutrition, made his farm an experiment in the production of healthy food. In 1886, he bred a strain of pig that produced disease-free pork, which he packaged with a No Cholera Here logo. He sold healthful foods regionally for many years. The house in the lower right of the photograph is still located at 13 Stillson Avenue.

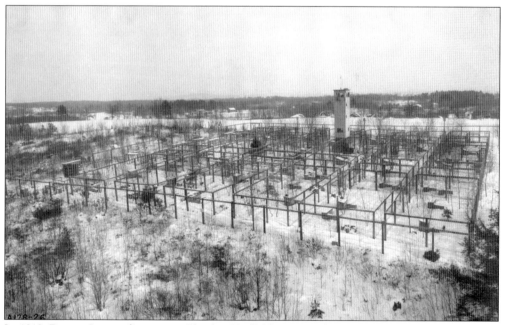

In 1919, Doctor Learned's stepson Charles Sheffeld converted part of the farm into a breeding area for silver foxes. These animals' pelts were made into stoles that were very sought-after and expensive fashion accessories. The animals were so valuable that high fences and a guard tower were erected to protect them. The coming of the Great Depression curtailed the market for such luxuries, however, and the enterprise failed in 1930.

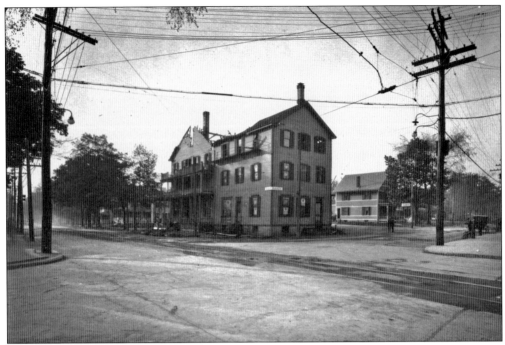

The Florence Hotel is shown here with its center and roof burned through. It was a very typical, large, wood-framed building. Likely heated with wood or coal, it caught fire and burned rapidly out of control. Afterwards, the building sat empty for some time until it was finally demolished.

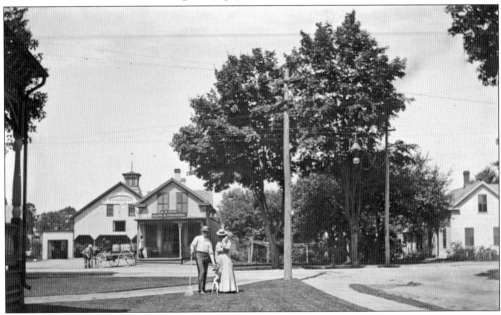

The front wood-frame building with the inviting porch is located at 52 Maple Street. It was built in the 1860s as a meat market by C.L. Warren, and different owners sold meat from this location for more than a century. Behind the meat market was a large barn, with a beautiful cupola and wide doors. This was the Grave's Brothers Livery & Feed Store, operated by Edward and George Graves.

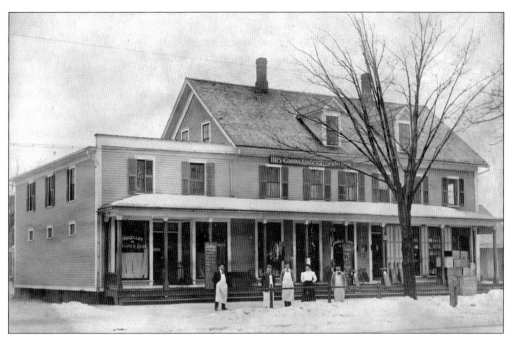

This plain wood structure at 40 Maple Street was built in 1865. It has a long history of many different owners, all offering various goods and services to the community. One of the first was early postmaster Henry F. Cutler, who ran the post office from this building. Today, the central tenant in the building is the popular Side Street Café.

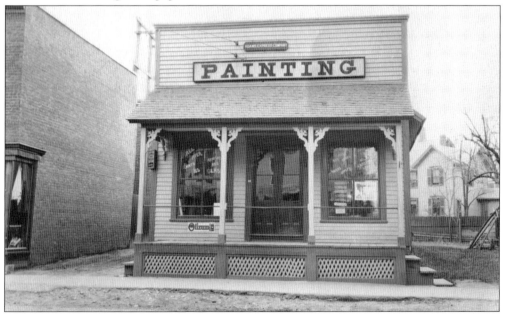

The building located at 12 North Maple Street was constructed in 1872. Here, Thomas Orcutt and Nathan Hussey ran a hardware business until 1879. Later, it operated as a Chinese laundry and several other businesses until George Churchill and George Busch began their painting and decorating store in 1897. In 1937, Francis Lamontagne took over the business and specialized in paint and hardware. Today, it is known as the Florence Hardware Store.

The Florence Tack Company was started by George Bond in 1874. Located inside a sprawling wooden building on Holyoke Street, the company manufactured all sorts of iron nails, tacks, and other fasteners. Unfortunately, the building was destroyed by fire in 1876. The company quickly rebuilt, but the weight of their massive debt and the competition from steel products forced them to close in 1892.

In 1906, the Northampton Silk Company, owned by Alexander McCallum, purchased the buildings of the former Florence Tack Company. McCallum started to produce silk hosiery and was quite successful for many years. The Pro-Phy-Lac-Tic Brush Company purchased the building in 1948 and constructed the rear addition. The building still exists today as the "Silk Mill," which houses several condominiums and medical offices.

Three
THE HOWES BROTHERS' VIEW OF FLORENCE

This house was once owned by John Stockwell and is located at 78 Chestnut Street. The one-and-a-half story, front-gabled structure is representative of the Florence Sewing Machine Company employee housing because it has had fewer alterations than others and has been well maintained since its construction in the late 1800s. (Courtesy of Historic Northampton.)

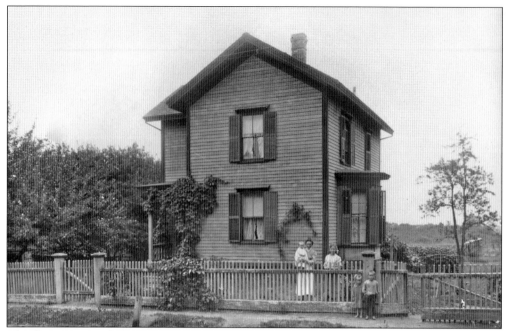

This house at 91 Chestnut Street was owned by Martin Paddock, who ran his custom tailor shop at corner of what are now Keyes and Main Streets in the old Branch's Block. (Courtesy of Historic Northampton.)

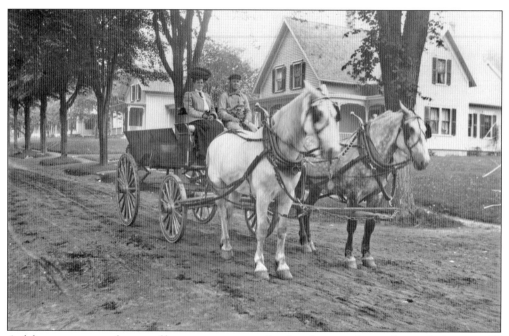

A delivery wagon and team of horses stop to pose for the photographer in front of a home at 87 High Street. The house is still there but has undergone many exterior changes over the years. (Courtesy of Historic Northampton.)

This family shows off their house at 67 High Street, which was home to Prescott W. Richards. Richards was employed as a shipping clerk for the Florence Manufacturing Company. (Courtesy of Historic Northampton.)

This three-apartment block at the corner of Chestnut and High Streets was originally built by the Florence Machine Company as housing for it workers. It was later sold to the Andrus family in the early 1900s. (Courtesy of Historic Northampton.)

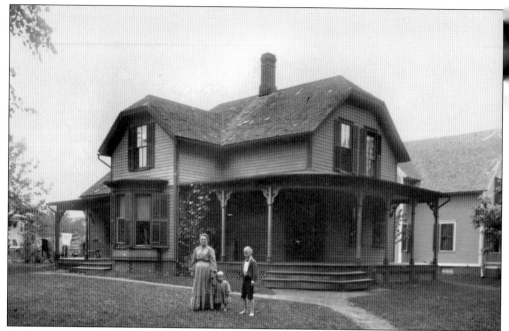

Fred Crossman once owned this house at 81 High Street. He was co-owner of Crossman & Polmatier, a hardware and plumbing store on North Maple Street. The partners also acquired residential lots in this neighborhood, developing homes on Stilson Avenue and High Street. (Courtesy of Historic Northampton.)

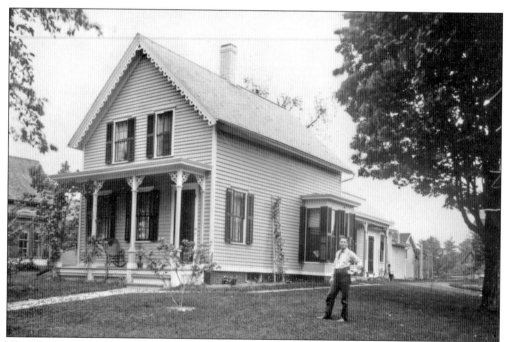

The house at 21 Corticelli Street was part of the Sullivan estate in the early 1900s. The gingerbread woodworking along the front roofline bears a striking resemblance to that of its sister house, located at 29 Keyes Street. (Courtesy of Historic Northampton.)

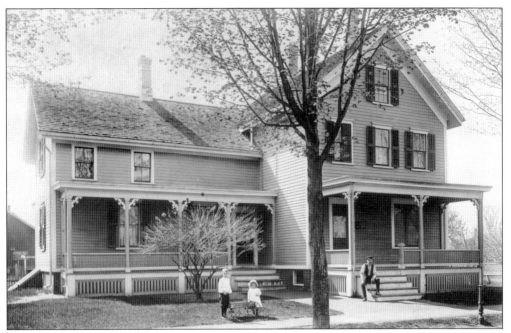

This two-family home was located at 16 Fruit Street, where the rear addition of the Florence Savings Bank now stands. It was once owned by Carl Carlson, who lived on one side and rented the other to Sven Gustafson. Later, William Hill bought this house and lived there with his family until it was torn down in the 1970s.

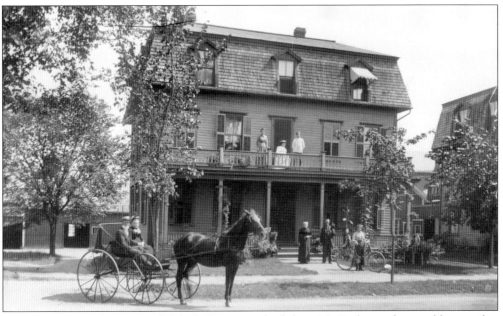

The Cottage Hotel at 17 North Maple Street was built by a Mr. Parker and was sold soon after to George Nye of Springfield. In 1901, Frank Twiss bought the building, where he operated a tavern. It was partially destroyed by fire in 1918, and in 1923, Cornelius Reardon reopened the hotel. More recently known for dining and entertainment, the Cottage Kitchen operated in this building throughout the 1980s and into the early 1990s. (Courtesy of Historic Northampton.)

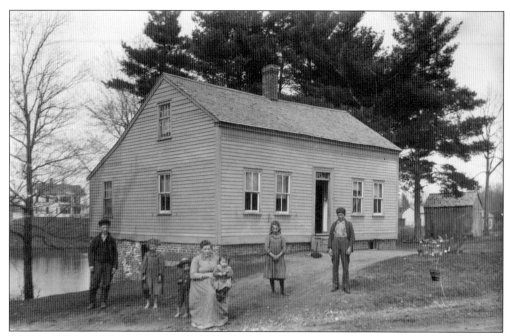

Built in 1817 by William Warner, the Polly Bosworth house was once located at 90 Park Street. It was moved to the corner of Lake and Warren Streets in 1873 to accommodate the construction of Cosmian Hall. The large pond in back was known as Frog Pond and was often used for ice-skating. Come springtime, local residents used to informally dredge the pond for compost to use in their gardens. (Courtesy of Historic Northampton.)

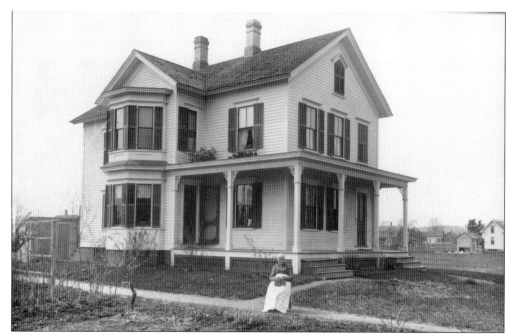

In the early 1900s, this two-family house at 68 Lake Street was home to nurse Alice Johnson, along with Zigmund Libiecki and Sophia Johnson. (Courtesy of Historic Northampton.)

The lot at 87 North Main Street was owned by Charles Calistus Burleigh, who moved to Florence in 1861. According to the census of 1870, he was living in a house on North Main Street next door to Charles B. Smith. The Florence map of 1873 also indicates that the Burleigh and Smith houses were at this location. (Courtesy of Historic Northampton.)

Lilly Street was laid out by Alfred Lilly in 1880, and this small house at 28 Lilly Street was built shortly thereafter. It was once owned and occupied by Walter Coleman, the Northampton manager of the New England Telephone & Telegraph Company. (Courtesy of Historic Northampton.)

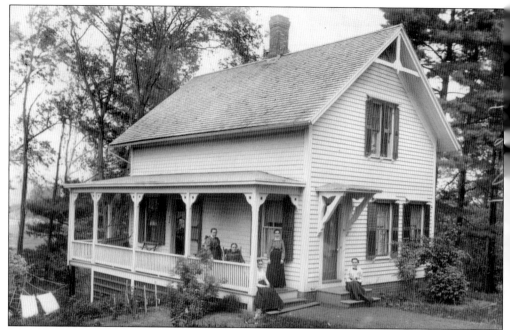

Prospect Street was laid out between 1859 and 1861 along the top of the western terrace of the Mill River. By 1873, much of the street had been developed with small cottages, most of which were individually owned and a few of which erected by two local industries: the Nonotuck Silk Company and the Florence Manufacturing Company. Prospect Street was later renamed Corticelli Street, and this house still stands at 34 Corticelli Street. (Courtesy of Historic Northampton.)

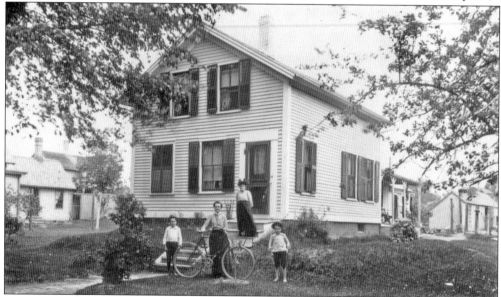

Located at 11 Corticelli Street, this is one-and-a-half story, front-gable house is three bays wide and four bays deep. It is almost identical to the house at 25 Corticelli Street. The asphalt-shingled roof has thinly boxed eaves that make no returns, a feature of houses built in the early 1870s. This well-maintained structure represents the high quality of workers' housing built in Florence during the 1870s; it was modest but constructed to last. (Courtesy of Historic Northampton.)

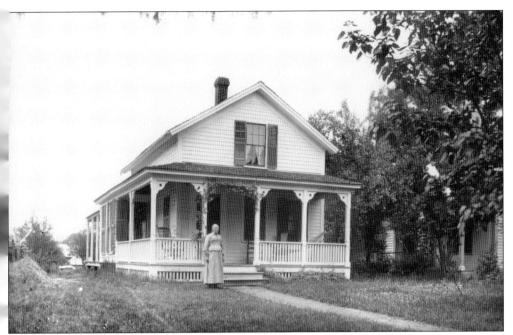

This small house, historically known as the Adeline Bowers House, is located at 36 Park Street. Three bays wide, it has a side-hall entry on the first story and a single window at the second story of the east facade, much like its neighbor at 32 Park Street. It represents the smaller, rental housing that went up on Park Street to accommodate families that came to work in Florence's industries. (Courtesy of Historic Northampton.)

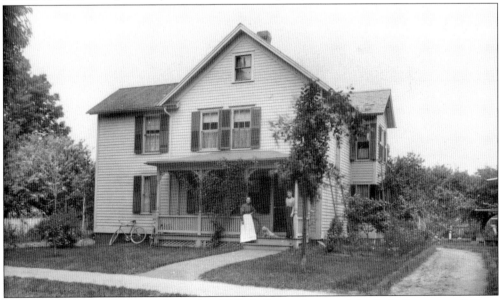

The Sojourner Truth house is located at 35 Park Street. It was originally built as a small Cape house and was later expanded to its current size. Sojourner was a former slave who came to Florence in 1843 to live in the "Community." She wrote her autobiographical narrative in 1850 using the proceeds from its sales to acquire this home. She lived here until 1857, when she moved to Michigan. (Courtesy of Historic Northampton.)

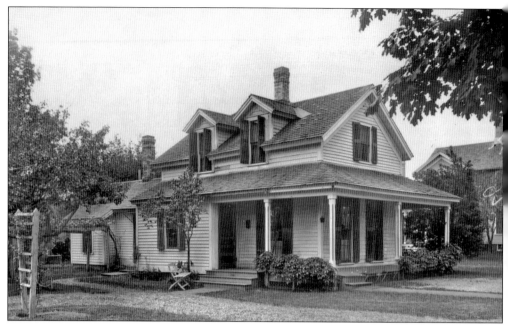

This small, character-filled house sits at 14 Pine Street with a comfortable wraparound porch, tall shutters, and two attractive dormers. The home was surrounded by a grape arbor, fruit trees, and flowering shrubbery. (Courtesy of Historic Northampton.)

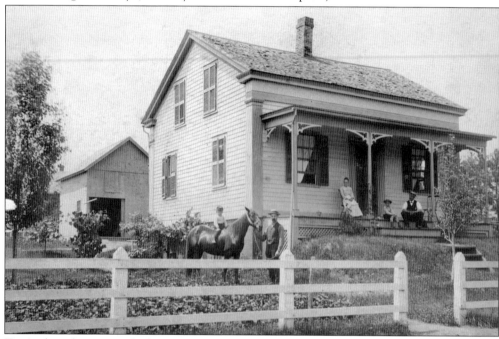

To avoid confusion over duplicate street names in Northampton and Florence, many of the street names in Florence were changed in the mid-1900s. Holyoke Street in Florence was located on what is now known as Berkshire Terrace and Straw Avenue. Once owned by John Jagu and his family, this lovely Cape-style house still exists today at 35 Berkshire Terrace. (Courtesy of Jason A. Clark.)

Four
Transportation and Street Views

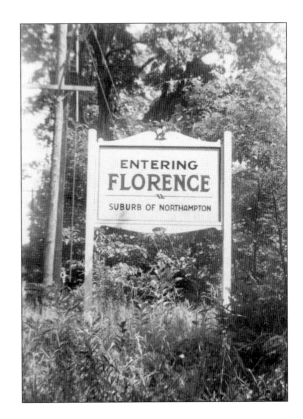

One of many projects taken on by the Florence Civic & Business Association over the years was the erection of this Entering Florence sign. The wooden sign, simple but pleasing to look at, welcomed visitors to the village of Florence near the veterans' hospital, on the Leeds border.

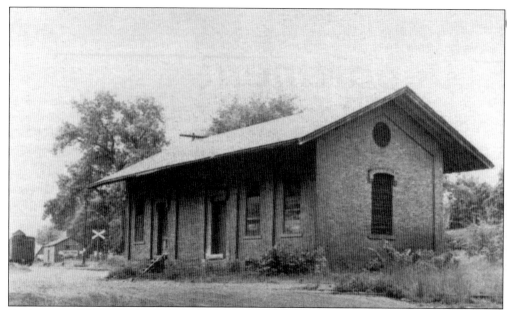

For just over 100 years, this little Florence depot stood between North Maple Street and Fruit Street. It was Florence's central transportation hub for passengers of the New Haven–Northampton railroad during the late 1800s. Unfortunately, times change. It was supplanted first by the city trolley system and then by cars and trucks. Unused for many years, it was demolished in 1969 and paved over for the parking lot along the north side of Depot Avenue. (Courtesy of Michael P. Flynn.)

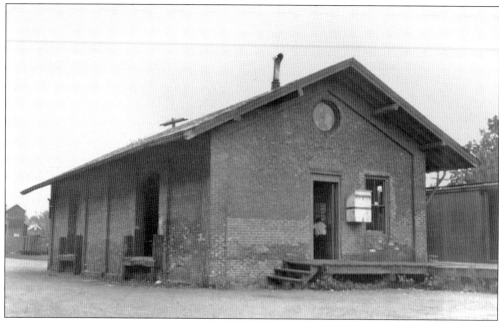

The Florence Freight House was built in 1867 when the Williamsburg Branch of the New Haven Railroad was being laid out. Purchases from a Sears or Montgomery Ward catalog would be delivered to the freight house, where residents could pick them up or have them delivered to their homes by the Railroad Express Agency. (Courtesy of Craig Della Penna.)

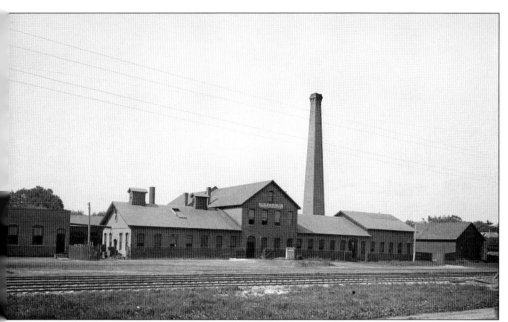

Many of the brick buildings seen here are located just west of North Maple Street and the former railroad tracks. Originally built for the Sheffield Manufacturing Company, which failed, this site was later owned by Bradford Couch, the Arthur Hill Machine Company, and the Norwood Engineering Company. No longer used for heavy manufacturing, the buildings now provide rental space for small businesses.

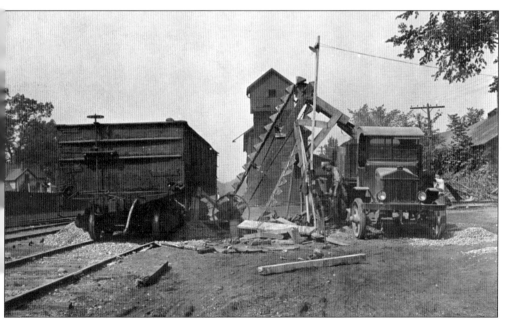

A team track is a small railroad spur intended for the use of area merchants or manufacturers. This photograph shows a team track in operation as gravel is being off-loaded from a railroad car to a truck using a conveyor. The gravel was to be used in construction of the Veterans Administration (VA) Hospital in Leeds. (Courtesy of the Florence Casket Company.)

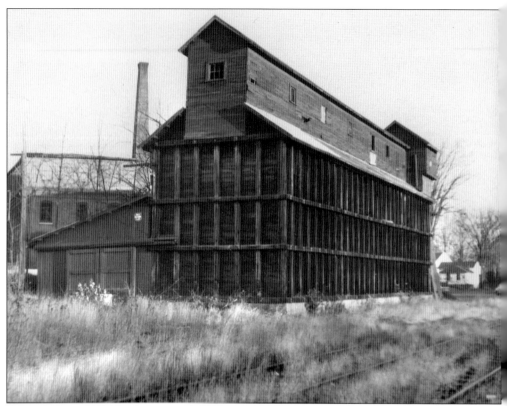

For many years, this freight barn stood between the Florence Casket Company and the rail lines on Bardwell Street. It was primarily used for the storage of coal, sand, and gravel. When it was demolished, many of the old chestnut beams were reused for construction of some newer local homes. (Courtesy of Richard Finck.)

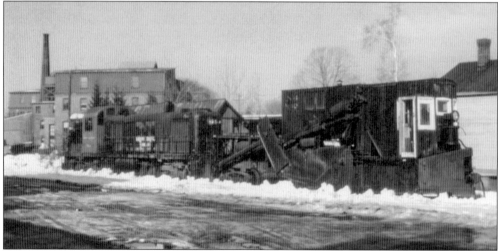

This view from the early 1950s shows the first-generation diesel locomotive and its specialized plow car, which was fitted with hydraulic arms to plow snow not only from between the rails, but also away from the sides and into the ditch line near the tracks. The Florence Casket Company is seen in the background. (Courtesy of Richard Finck.)

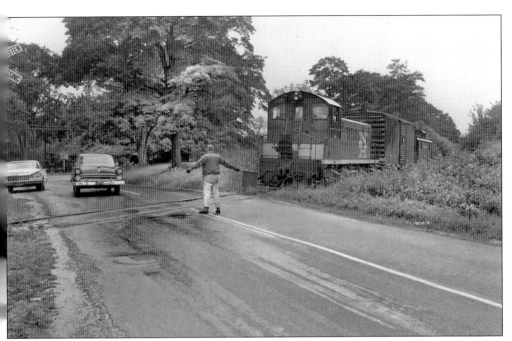

In the summer of 1962, this was the last train from Williamsburg crossing Bridge Road. When approaching the intersection, the train slowed to a stop, and the flagman jumped off the front to stop the traffic. In the background, the entrance of Look Park is visible behind the two cars.

Thomas Orcutt and I.M. Davis operated an undertaking and carriage-building business here around 1879. Edward O'Donnell later managed the O'Donnell Grain Store in 1932. Built in two sections, the rear addition was built at an angle to accommodate Depot Avenue with a cutoff to the right of the building, which allowed the trains to back into the Norwood Engineering building on North Maple Street. Florence Cleaners now occupies this building.

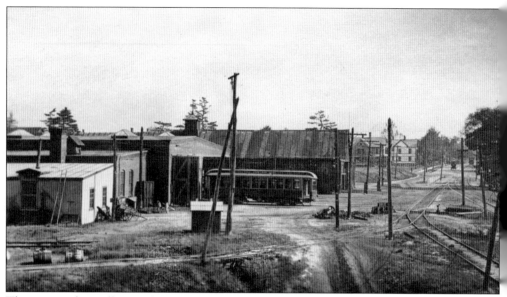

These were the trolley car barns. Here, cars were stored, repaired, and made ready for each day's work. Looking down Locust Street, it appears that three separate sets of trolley rails have engulfed the roadway. An approaching Model T is trying to find its way by maneuvering around all of the tracks.

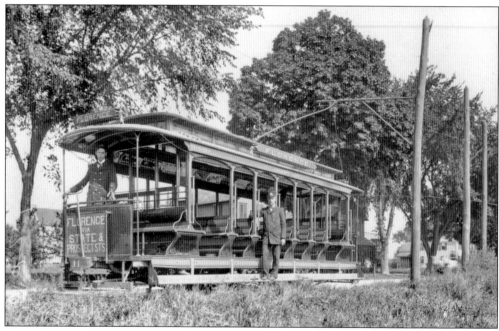

Two stalwart motormen stand proudly with their beautifully ornate electric trolley. Riding in this open-air car on a nice day, accompanied by a breeze and the sound of steel wheels on the rails, would be a very pleasant and interesting excursion. (Courtesy of Historic Northampton.)

For a short time after the horse cars were phased out, this car with a platform mounted on its roof was used to install the overhead wires for the incoming electric trolleys.

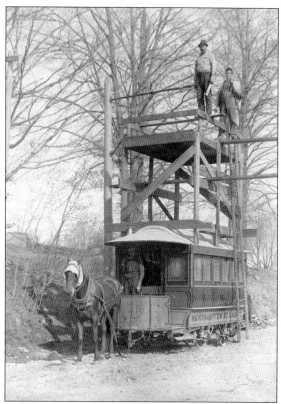

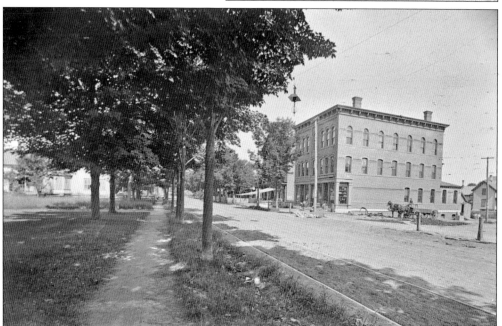

In addition to transportation, the trolley cars provided a low-speed view of the tree-lined Main Street and its buildings, architecture, and people. Seen here in the late 1880s is a newly built Knights of Honor Block.

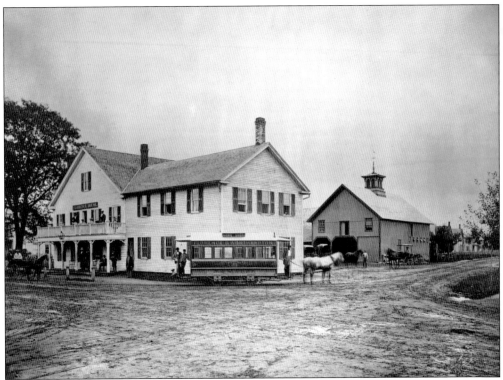

Here, a horse car has made the trip from Northampton to Florence. It will now turn left and head down Maple Street to Pine Street, where many people will get off and take a short walk to work at the mills.

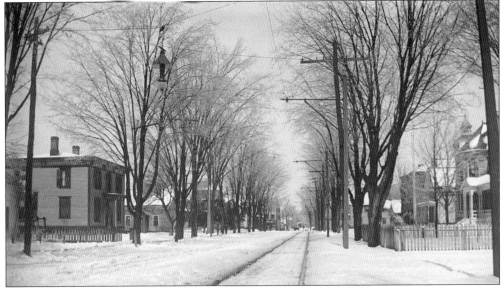

One would have to bundle up for this chilly trolley ride along Maple Street in the late 1800s. In this driver's perspective approaching the center of the village, a horse can be seen crossing the intersection of Main and Maple Streets. Overhead are the trolley wires necessary to electrify the cars.

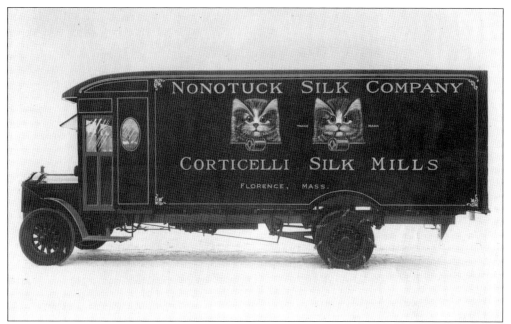

The Corticelli Silk Mills had the ability to incorporate art in their advertising, and Charles Sheffeld designed the very popular kitten logos. An example is prominently displayed on one of their delivery trucks in the 1920s.

Frank Keyes began his floral business in 1904, and it was handed down through four generations of the family. The retail shop had several different locations before being consolidated at 29 Keyes Street. This photograph shows an early Keyes Flowers delivery vehicle. (Courtesy of Ned Gray.)

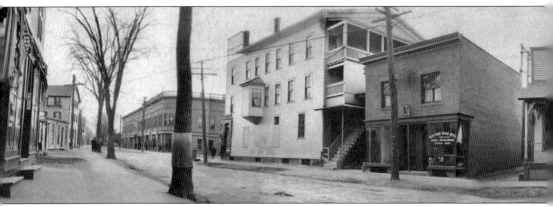

In the panoramic view of North Maple Street spanning the top of these two pages, Parsons Block and the Maine Block are both seen on the opposite side of the street. To the left of the hardware store was 10 North Maple Street, which was home to the New York Shoe Store. It was demolished in the later 1960s. The building in the middle, at 12 North Maple Street, is now occupied by

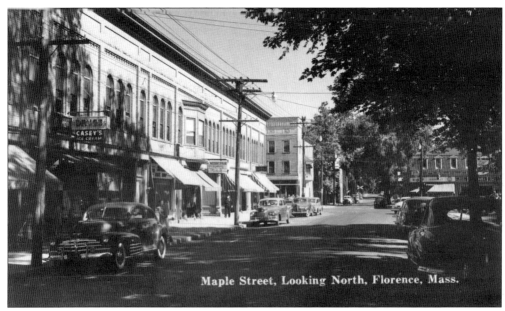

A police officer is making his early morning rounds, perhaps on his way to grab a coffee from the Model Bake Shop, in this late 1940s view of the Parsons Block. Herlihy's and Moriarity's Drug Store are seen farther to the left.

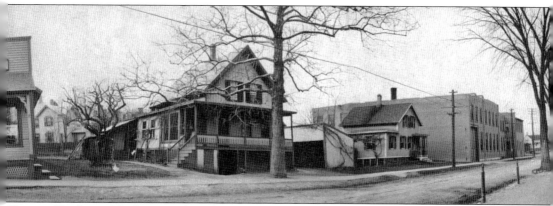

Florence Hardware. The house to the right of it was the home of Walter Corbin (the photographer of this picture) and his wife, Lottie, for many years. James O'Connell lived next to the Corbins, and further in the distance is the Norwood Engineering Company. (Courtesy of David West.)

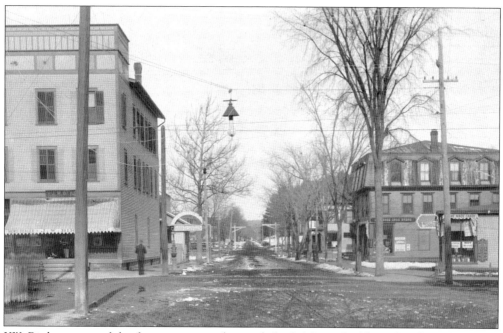

J.W. Bird was one of the first tenants in the newly built Maine Building. On the right side of Maple Street is the old Florence Drug Store, with a sign advertising Whitcomb's cigars. Directly across the street is the Crossman & Polmatier hardware and plumbing store.

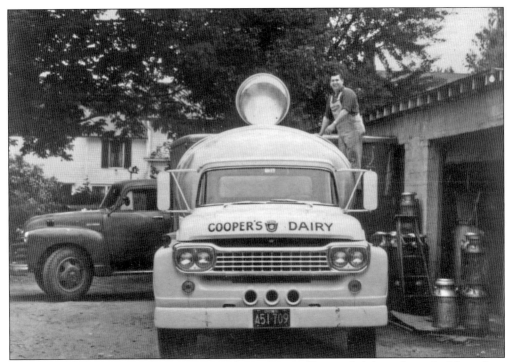

Russ Cooper began his days sometimes as early as 2:00 a.m. He traveled throughout the Hampshire and Franklin counties to pick up raw milk and bring it back to his dairy in Florence. There, it was pasteurized, homogenized, and bottled up for delivery to area homes and stores. (Courtesy of Rich Cooper.)

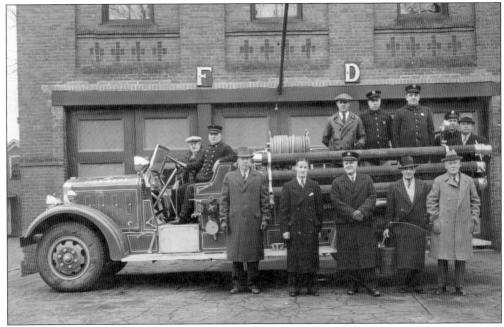

Posed in front of the Florence Fire Station in December 1936, several intrepid firefighters and city officials proudly display a brand new Buffalo Pumper Fire Truck.

Five
ABOVE IT ALL

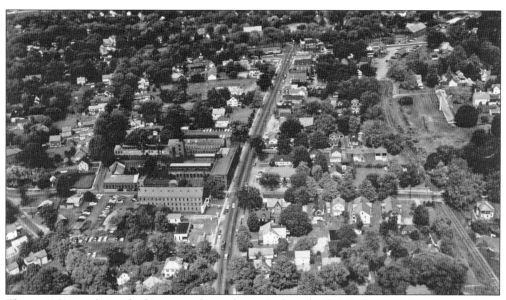

This c. 1950 aerial view looking west shows the entire length of Main Street. Many changes have occurred along this road over the years, but Florence still retains its village charm.

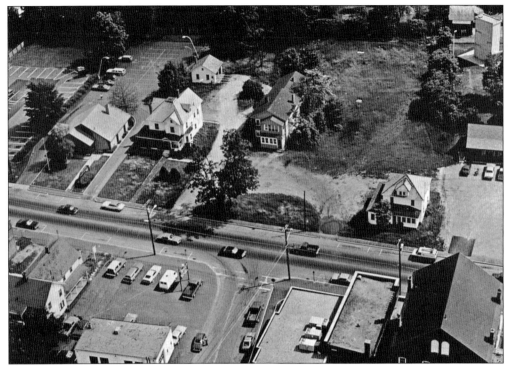

This photograph looks down on the Main Street and Keyes Street intersection. The Florence Savings Bank is in the lower right side, and Florence Pizza is now located in the building seen in the upper left corner. The three houses to the upper right were all demolished to make way for the Florence Medical Offices. (Courtesy of the *Daily Hampshire Gazette*.)

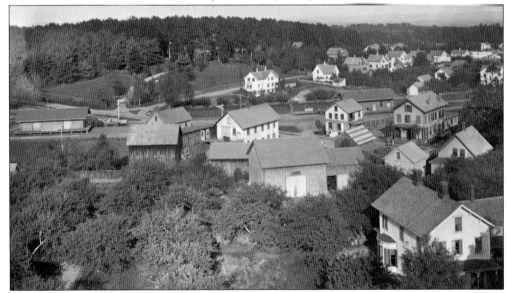

This early 1880s view looks north from the Cosmian Tower. This view shows the Maple Street and Pine Street neighborhood before the Norwood Engineer buildings were constructed. An old freight depot is visible to the far left, and the passenger station can be seen in the right side along Depot Avenue.

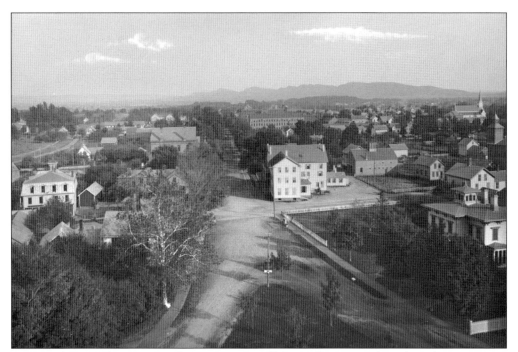

An easterly view of Main Street from Cosmian Hall shows the corner of Maple and Main Streets. The Florence Hotel dominated the corner in the years before the Parsons Block was built across the street.

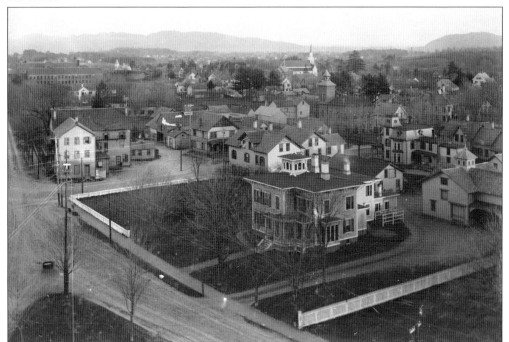

This perspective of the Parsons Mansion shows the large estate before the Parsons Block was built. A white picket fence outlines the property along Meadow and Maple Streets, and a large livery barn stands just behind it.

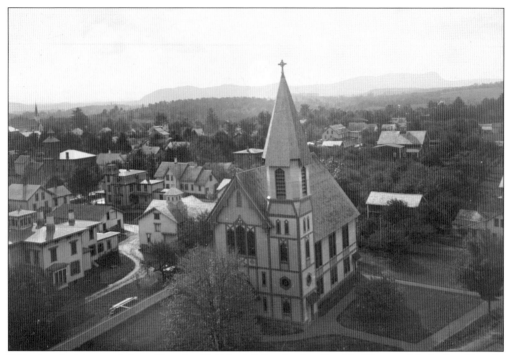

This view, looking south from Cosmian Hall, highlights the details of the Florence Methodist Church, with the building's original steeple and lovely wood framework featured front and center.

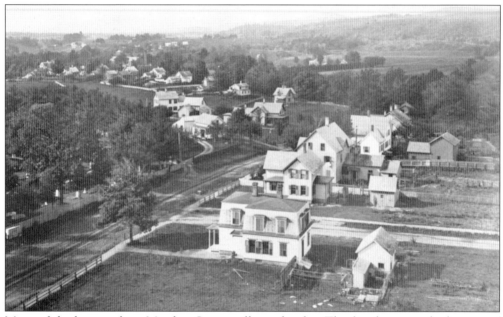

Many of the houses along Meadow Street still stand today. The first house at the bottom of this image is located at 21 Meadow Street. Built in the early 1880s, it was once the home of Gary Emerson.

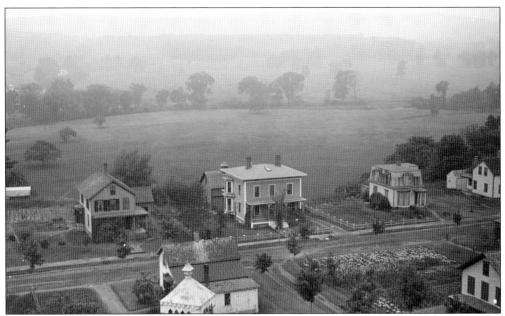

Many of the houses on Lilly Street were constructed in the 1880s. To the left is 18 Lilly Street, which was once home to Ella Elder, principal of the Florence Kindergarten. In the middle is 22 Lilly Street, and 28 Lilly Street is toward the right side.

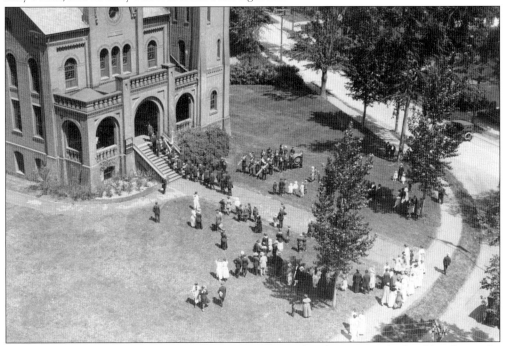

The next nine photographs were all taken from the top of the Florence Methodist Church steeple. The structure still exists as the Florence VFW, but the steeple was removed in the early 1970s. During the early 1900s, Walter Corbin took a number of stunningly detailed photographs from this vantage point. This first view is looking down at the Cosmian Hall and a small gathering of people on the front lawn.

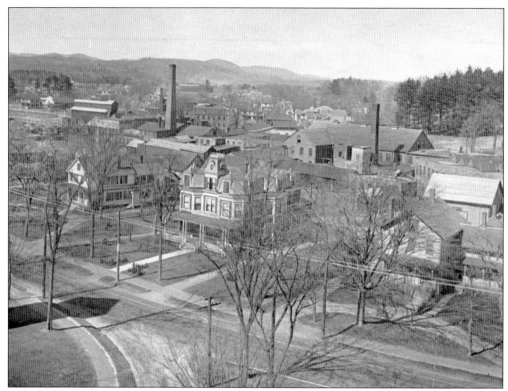

A northerly view shows the Davis House, located at 35 North Main Street, in the center. The house to the right is 21 North Main Street and was built in the 1860s. To the far left is 41 North Main Street, and in the distance, just to the right of the larger smoke stack, the Florence Casket Company can be seen.

The view of the Maine Block from atop the Methodist church would not appear that different today. The Maine fountain can be seen in the lower right, and many familiar buildings stand along North Main and Maple Streets.

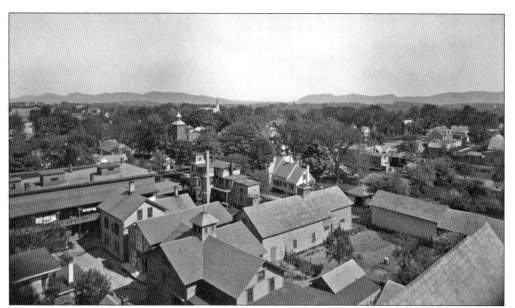

These rooftops are the buildings that were located behind the Parsons Block in the early 1900s. The old fire tower is visible in the center of the picture, and the Annunciation Church steeple can be seen in the distance. Along the horizon is a wide view of the Mount Holyoke Range.

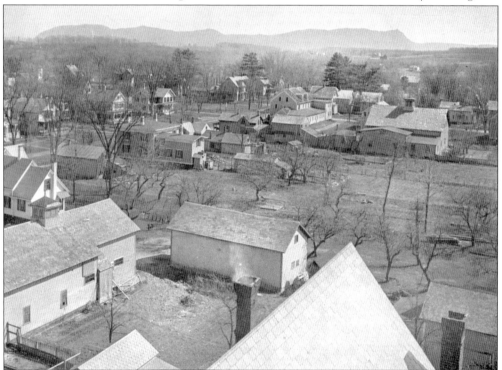

This view is looking south toward the Maple Street and West Center Street neighborhood, where Tobin Manor is now located. The large barn with the cupola, toward the right side of the photograph, is the Graves Livery Stable. A closer look at the right side of Mount Tom reveals the old Summit House, which burned down in 1929.

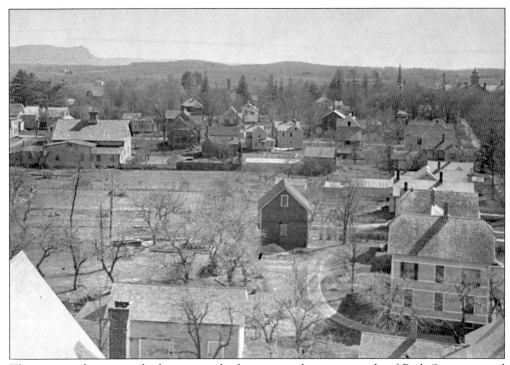

This is a southern view looking over the houses on the eastern side of Park Street toward Pine Street.

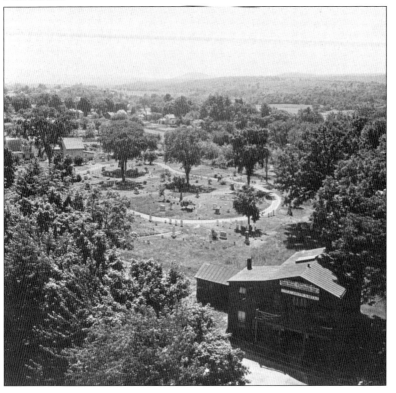

M.C. Howard was located on Park Street, directly in front of the Park Street Cemetery. A number of Florence's prominent early citizens are laid to rest here, including Samuel Hill, Charles Sheffeld, Alfred Lilly, and many more. Services are often held at this cemetery after the annual Memorial Day parade.

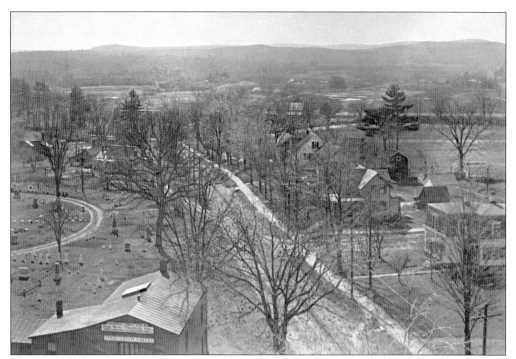

This turn-of-the-century view to the west shows the houses along Meadow Street heading down toward the Florence Meadows.

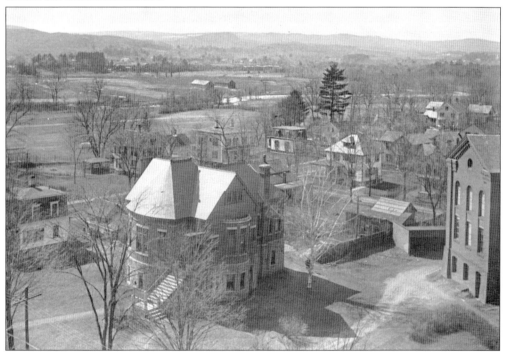

This photograph from the Methodist church is looking down at the Lilly Library on a crisp, clear winter afternoon. Just past the houses along Lilly Street, the Mill River can be seen flowing along its course through the Florence Meadows.

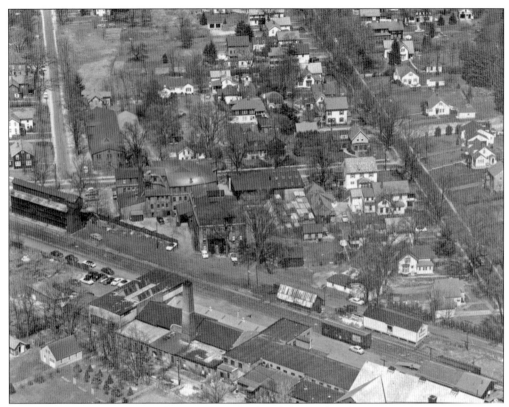

An aerial view of the Bardwell Street neighborhood shows the Florence Casket Company and the old freight houses along the rail line. (Courtesy of the Florence Casket Company.)

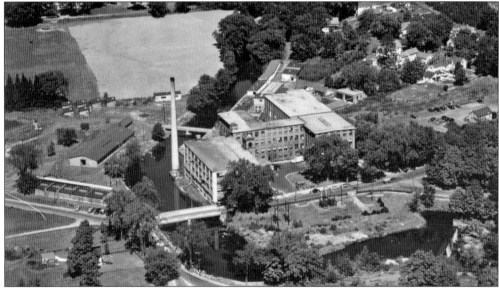

The intersection of Spring Street and Florence Road had not yet been moved when this photograph was taken. The large smokestack rises above building, which was owned by Pro Brush and is now under new ownership, houses the Arts & Industries at 221 Pine Street.

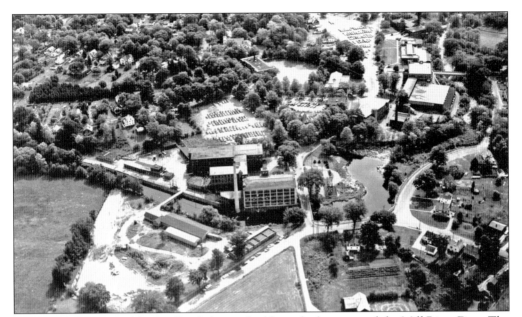

This is another view of the Pro Brush factory buildings, looking toward the Mill River Dam. The parking lots are filled with cars along both Pine Street and Nonotuck Street. In the top center is the rectangular building of the Florence Grammar School, more recently known as the Florence Community Center.

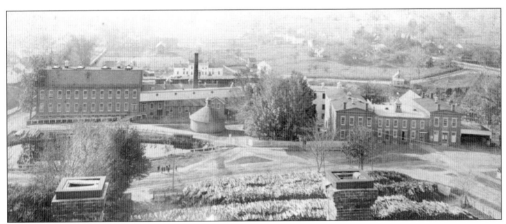

The top of the original Florence Grammar School provided a great location from which to view the numerous buildings belonging to the Corticelli Silk Company. The body of water on the left side of the photograph was part of the extensive canal system that powered the machinery in the factory buildings. (Courtesy of Jason A. Clark.)

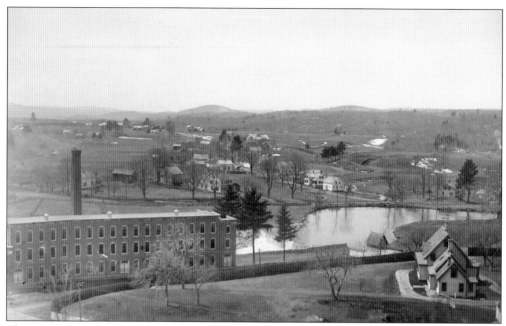
The area now known as Ryan Road resembled more of an open meadow around 1900. Many of the trees were likely cleared for construction materials and firewood throughout the 19th century.

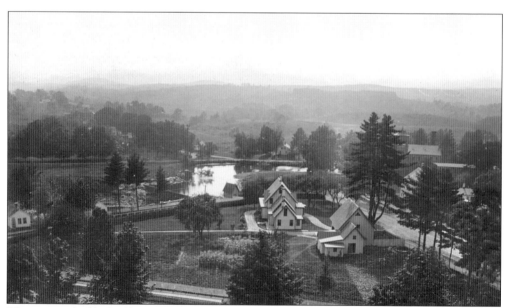
The estate of Alfred Lilly can be seen in this westward view from the schoolhouse. This land is now occupied by the Pine Street Plaza, where Brooks Drug Store stood for several decades. The Mill River Dam can be seen just to the left of Lilly's house.

Six
ALONG THE MILL RIVER

A postcard view taken by Walter Corbin, and looking across the Mill River from the Florence Meadows, shows a peaceful summer scene. In the distance and to the left, the Cosmian Hall Bell Tower peeks over the trees. (Courtesy of Jason A. Clark.)

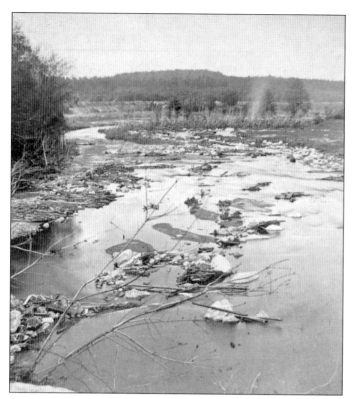

This view is looking toward the Florence Meadows after the Mill River Flood in 1874. The flood was the result of a dam break in the town of Williamsburg. The reservoir was 111 acres in size with an average depth of 24 feet, and once the dam failed, the water rushed downstream with such force that it devastated the towns of Williamsburg, Skinnerville, and Leeds. (Courtesy of Historic Northampton.)

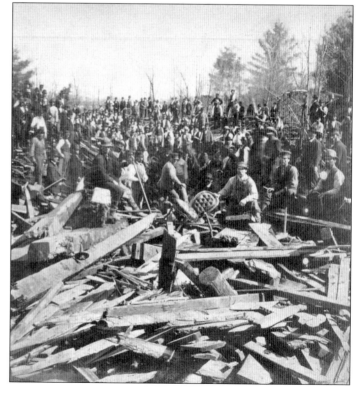

The flood swept away several bridges and some smaller buildings, but Florence was spared the devastation experienced upstream because of the layout of the land. The floodwaters spread across the wide area of the Florence Meadows, leaving behind acres of debris from the towns above. Looking carefully along the river today, one can still see scattered pieces of eroded bricks from the buildings that were destroyed that day. (Courtesy of Historic Northampton.)

Immediately after the floodwaters receded, the search for missing bodies began. Once used by William Warner as a workshop, this house sadly became the site of a makeshift morgue. Of the people who perished in the floodwaters, 42 were found in the Florence Meadows and brought to this little house on North Main Street. Following the flood, this structure became known as the "Ghost House." (Courtesy of Look Memorial Park.)

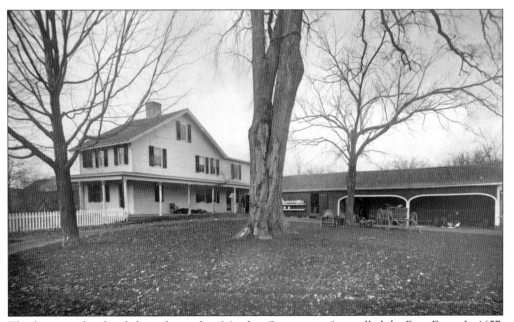

This house and its lovely barn, located on Meadow Street, are often called the Ross Farm. In 1657, John Broughton was granted title to this fertile meadow. Samuel Whitmarsh acquired the property in 1835 and grew mulberry trees to feed his silkworms. The next owner was the Northampton Association of Education and Industry. When it dissolved in 1846, the meadow was purchased by Austin Ross, whose family owned the farm until 1927.

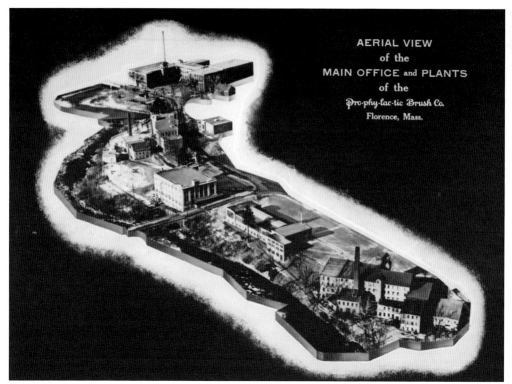

This advertising composite photograph and map shows the substantial holdings of the Pro-Phy-Lac-Tic Brush Company. Over time, the "Pro" grew to this large size through the acquisition and consolidation of all the companies formerly located along the Mill River. The river itself could be called the "ribbon of life" thanks to the flow of water that, harnessed by dams and wheels, created the energy to power these mills.

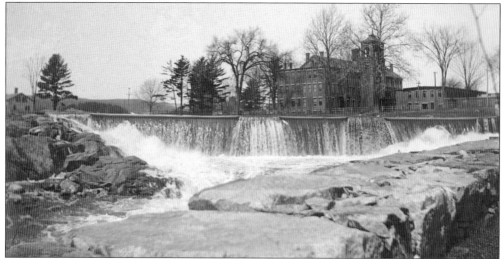

In the foreground, a stone wall directs the flow of the Mill River as it rolls over the original Nonotuck Silk Mill Company Dam. Above the dam, the five-story brick structure with its many windows and tall tower was originally built by the Florence Manufacturing Company. Through time, it passed into the hands of the Pro-Phy-Lac-Tic Brush Company.

This Knowlton Brothers photograph shows the Florence Manufacturing Company with an iron bridge that crosses the Mill River, connecting Pine Street to the Florence Meadows. In 1874, the floodwaters carried the Meadow Street Bridge downstream, where it slammed into the iron bridge on Pine Street, and both bridges were washed over the dam below. (Courtesy of Historic Northampton.)

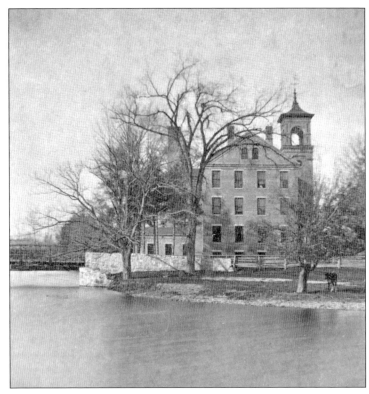

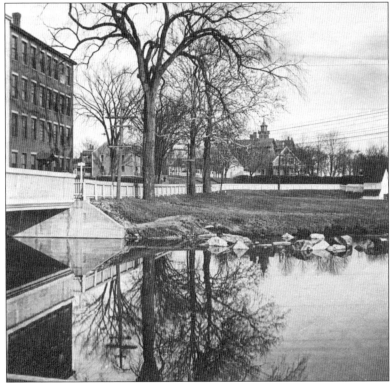

A view across the Mill River shows a newer concrete bridge with the factory building of the Florence Manufacturing Company towering over it. Behind the trees, just past the factory building, is an old boardinghouse. In the distance is the residence of Alfred T. Lilly, which was located at the site of the current Pine Street Plaza.

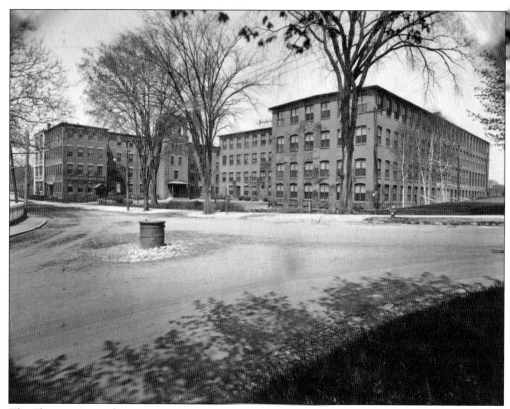

The Florence Manufacturing Company was organized by George A. Burr, Isaac S. Parsons, Sam Hinckley, and George Scott in 1866 and was later sold off to Littlefield, Parsons & Company, who manufactured daguerreotype cases and buttons. The original factory building is seen to the far left, and the two large additions to the right were constructed on the site of the former boardinghouses.

These were the early buildings of the Nontuck Silk Company. Inside were rooms dedicated to growing the silk worms, sorting the cocoons, processing the silk strands, and packaging the finished product. The I.S. Parsons Store, located in the right side of the building, was one of the earliest stores in Florence. Many other businesses were established in town by former employees, thanks to the expert training and financial help given by Mr. Parsons.

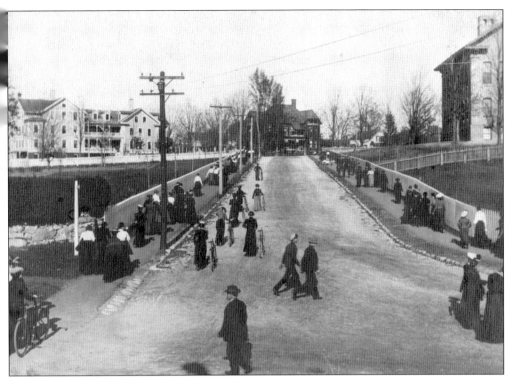

This view from the corner of Nonotuck and Prospect (later Corticelli) Streets shows a broad walkway. To the left is the silk mill boardinghouse. In the center is the Samuel Porter residence, and to the right is the corner of the Florence Grammar School.

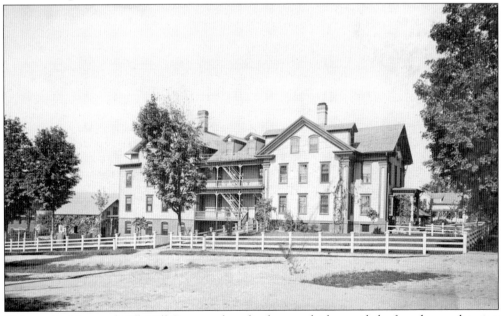

This was the Nonotuck Silk Mill Company boardinghouse, which provided safe and secure housing to employees and helped maintain a viable workforce. It was located on the corner of Pine and Prospect Streets and was later demolished to make way for more manufacturing space.

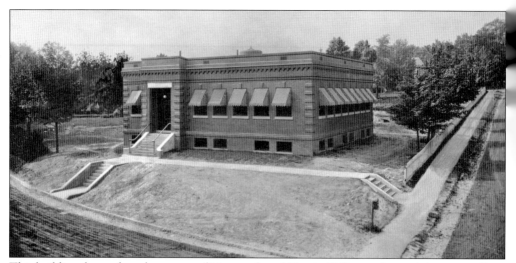

This building, located on the corner of Nonotuck and Corticelli Streets, housed the main offices of the Corticelli Silk Mill Company. Possibly for security reasons, a tunnel was built from the basement offices of this building, down under Nonotuck Street, and directly into the lower level of the Corticelli Mill. Today, this building still exists, but it has been physically incorporated into the Pine Street Plaza.

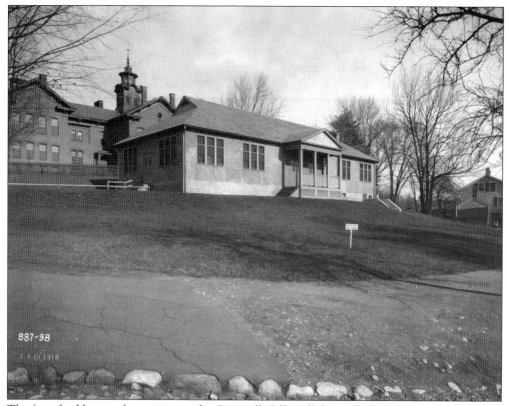

The front building in this scene was the Corticelli Silk Mill dining hall. The company provided this benefit to help maintain the nutrition and health of the workforce. Today, the building is still visible, but its simple architectural character has been obscured by several modern additions.

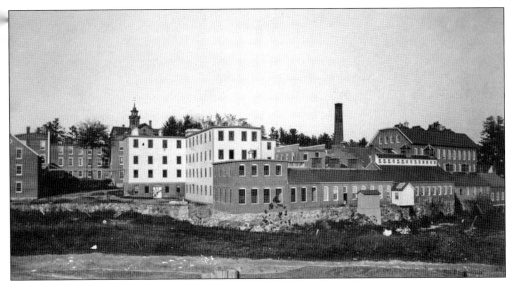

In this rear view of the silk mill, the brick dye house can be seen to the right. The middle section was built in 1862, with many additions added on throughout the next 20 years. The white building in the center of the picture was originally built in 1852, with an addition in 1888. The dye house has since been removed, and several additions have been added onto the buildings to the left.

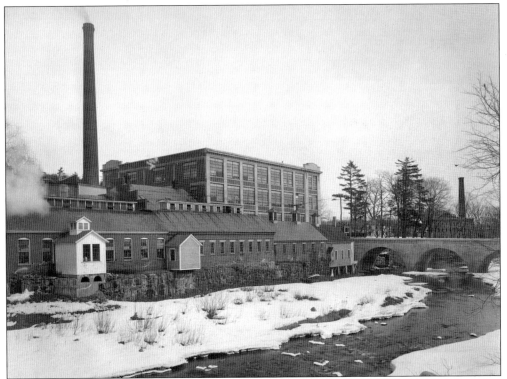

This is a view looking across the Mill River at the dye house. At the end of each day, excess dyes were allowed to flow into the river, likely from the two drains just below the small white structure to the lower left. The taller structure with the large windows was built in 1920 and used by the Corticelli Silk Company for manufacturing hosiery.

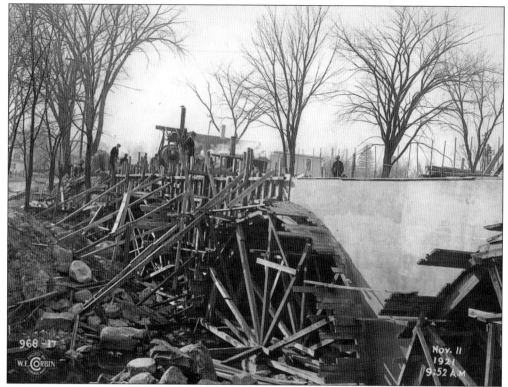

This 1921 photograph shows the substantial amount of preparation that went into creating the arches of the concrete bridge. Once competed, this bridge provided the employees of the Corticelli Silk Company quick access between Bliss Street and Nonotuck Street. The bridge stood the test of time, lasting 84 years before a new bridge was built in its place in 2005.

Originally built for the Northampton Silk Company, this photograph shows the mill that was located at the beginning of what is now Riverside Drive. The central part of the structure was built in 1837 and later expanded on either side. In the early 1840s the building was converted into a boardinghouse for the Northampton Association of Education and Industry and later became used as the lower braid mill for the Corticelli Silk Company.

Seven
RECREATIONAL PLACES AND EVENTS

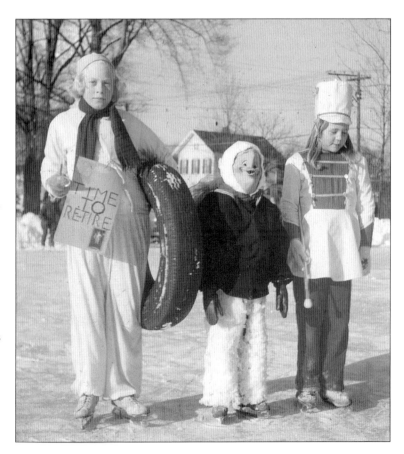

The ice-skating rink on Cosmian Green was popular throughout the 1950s and 1960s. In the winter, weekend afternoons were spent skating at the fun-filled events sponsored by the Florence Civic & Business Association. Children's Day on the rink was an opportunity to dress up in your best homemade costume and compete for one of three first-place prizes awarded within each age bracket.

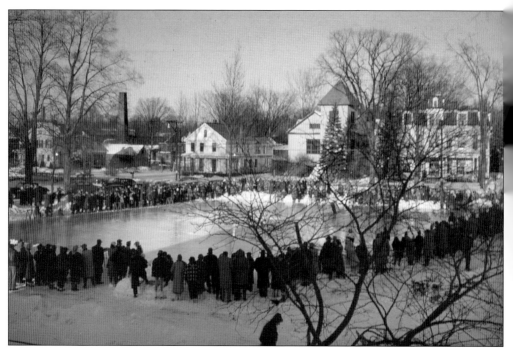

In January 1955, long, cold nights would give volunteers the right weather to make perfect ice, but it would require all-day and all-night dedication. After schooltime, the skaters would start to arrive, sometimes by the hundreds, to skate well into the evening. In those days, it was a social event, a fun time when people could stay outside with their friends and enjoy the ice.

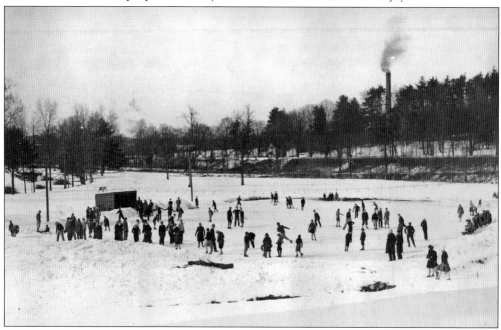

Look Park also offered a skating rink in the 1950s, situated in the proximity of the present-day tennis courts. It was quite popular, as this image attests. In the background is the smokestack of the VA Hospital.

Skating in the winter at Arcanum Field next to Bridge Road was great fun for kids, but how did the field come to be? Today, few people know that this field, now owned by the City of Northampton, was a generous gift from the early Arcanum baseball teams and their dedicated families, friends, and fans.

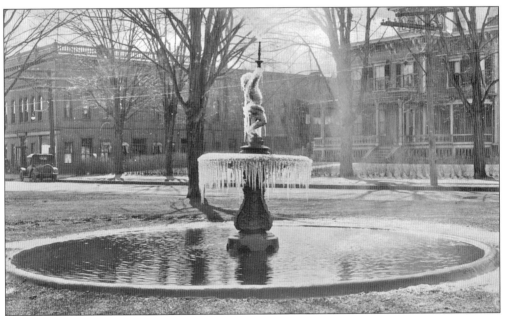

This winter scene shows the fountain in what is now known as Kolodzinski Park. In the background, the old Parsons House and the brick Parsons commercial block can be seen, along with a sleek 1930s roadster parked near Bird's store. (Courtesy of the *Daily Hampshire Gazette*.)

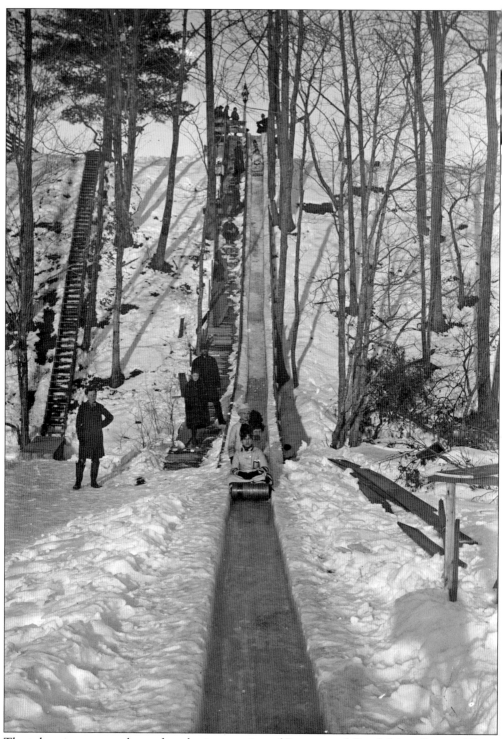

The toboggan run was located at the intersection of Beacon and South Main Streets. Those who had the courage to step off the street, over the fence, and onto an awaiting toboggan were in for the ride of their lives.

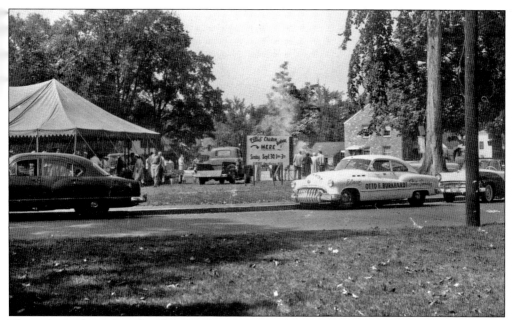

Throughout the 1950s, the Florence Civic & Business Association held annual barbecues on the Cosmian Green. Republican Otto Burkhardt strategically parked his car in front of this September 1956 event. Perhaps his visit to the barbecue gave him the slight edge he needed in the elections a few weeks later, as he defeated Democrat John O'Rourke by only three votes to win a seat as state senator.

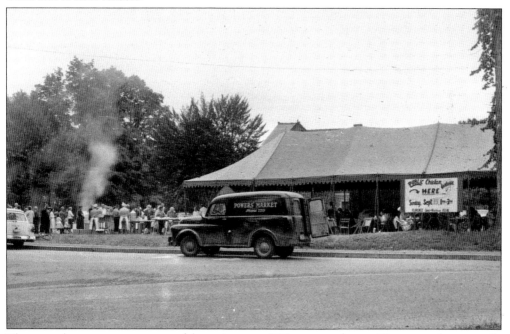

The annual event was very successful, serving up to 500 guests each year. The proceeds eventually helped to cover the cost of the purchase of the Cosmian Green. This photograph, taken in September 1957, shows the delivery truck of Powers Market dropping off supplies for the event. The annual barbecue has been revived over the last 10 years and is as successful as ever.

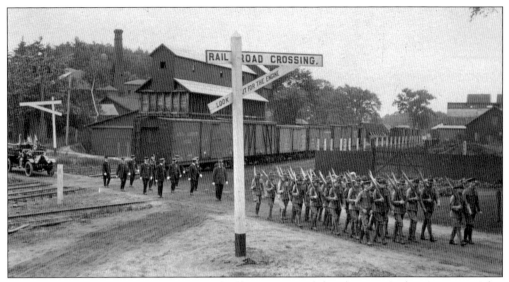

This view from 1918 looks east across Bardwell Street toward the Florence Casket Company. This parade concluded its march in front of Cosmian Hall, where the village held services to celebrate the Fourth of July and to honor the Florence residents who were serving in World War I with a memorial Roll of Honor and a new flagpole.

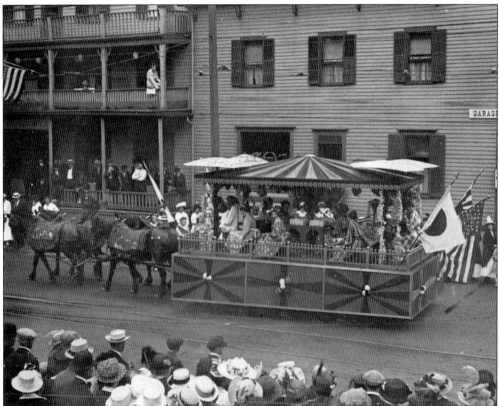

Spectators lined the streets and filled the porches of the Florence Hotel as the Corticelli Silk Company float rolled by in this early 1900s photograph on Main Street.

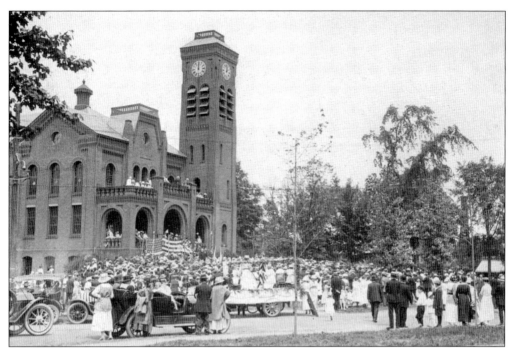

Cosmian Hall was often called the "Temple of Free Speech." For many years, parades and other special events frequently gathered at the steps, where they would hold their final ceremonies of the day.

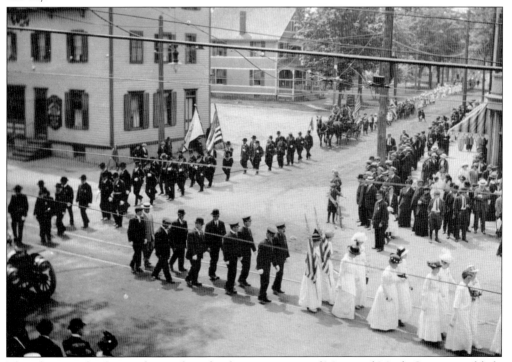

This photograph of a parade marching by the intersection of Main and Maple Streets was likely taken from a second-story window of the Maine Block.

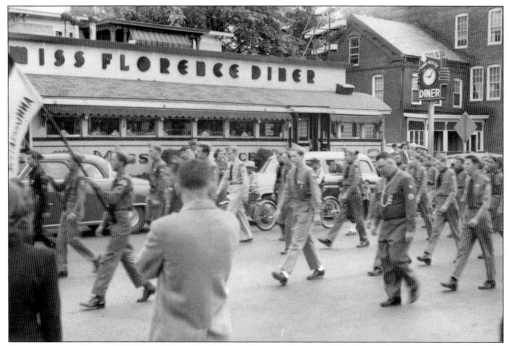

Scoutmaster George McDonald leads the Boy Scouts Troop 103, of the Annunciation Church, down Main Street during a Memorial Day parade. (Courtesy of Gordon Murphy.)

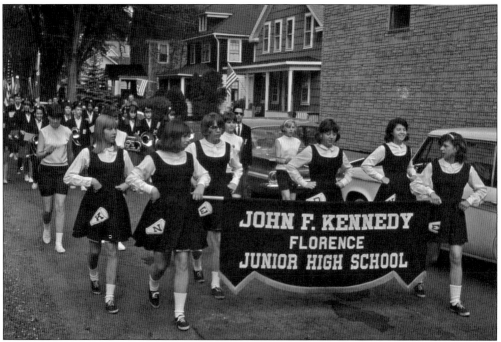

The cheerleaders of the John F. Kennedy Middle School march down West Center Street during the Memorial Day parade in 1966. Providing music and an energetic spirit, the local schools have always played an important part in the village parades.

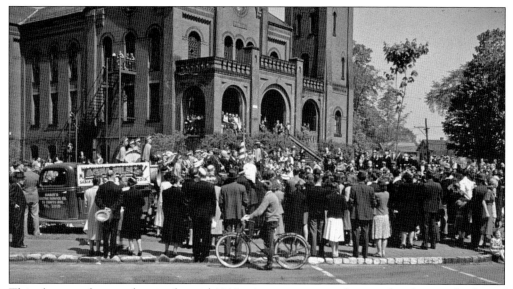

This photograph was taken in the mid-1940s. As in years past, the crowd gathers at the foot of Cosmian Hall. The condition of the building was rapidly deteriorating by this point, and it was demolished only a few years after this picture was taken. The truck parked on the lawn belonged to Sabin's Electric Service of 26 Crafts Avenue.

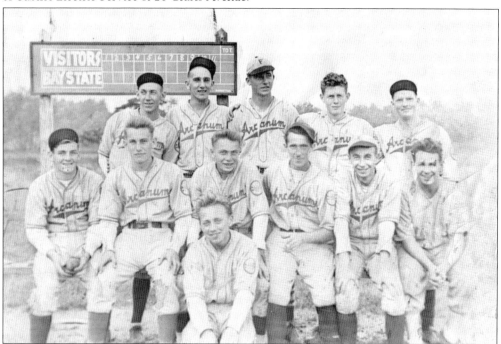

Many members of this Royal Arcanum baseball team enlisted early to serve their country in World War II. Despite intense action, all would come through uninjured and return home to their families. Pictured from left to right are (first row) bat boy Henry "Unk" Ankudowitch; (second row) Ed Cox, Russ Christenson, Fritz Lieberwirth, Mike Griffin, Valerta Moraski, and Frank Boynton; (third row) Henry Cox, Victor Christenson, Marvin Banister, Harry Rhoades, and an unidentified young man.

Julius Maine was a successful businessman who operated a meat market on North Maple Street. Later in his life, he began to give part of his fortune back to the community in an event called a "marble scramble." On the day of the scramble, Maine would dress in his butcher's apron and throw pails of marbles and pennies to the kids in the crowd. It would be a raucous and festive day for all involved.

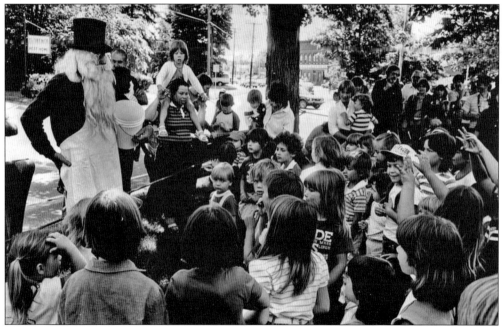

In 1984, members of the Florence Civic & Business Association revived the marble scramble in the form of Julius Maine Day. An excited crowd of children once again gathered around Julius Maine (as portrayed by Vic Christenson, in costume) at the Kolodzinski Park. (Courtesy of the *Daily Hampshire Gazette*.)

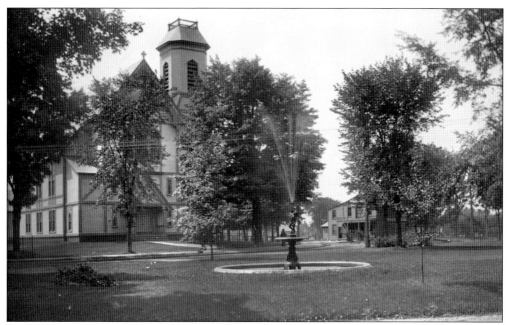

This impressive summer scene shows the park at the corner of Meadow and North Main Streets (now known as the Kolodzinski Park). The old iron fountain stands gracefully in the center, and behind the large trees stands the Florence Methodist Church, with M.C. Howard visible in the distance. A stone fountain later replaced the one seen here.

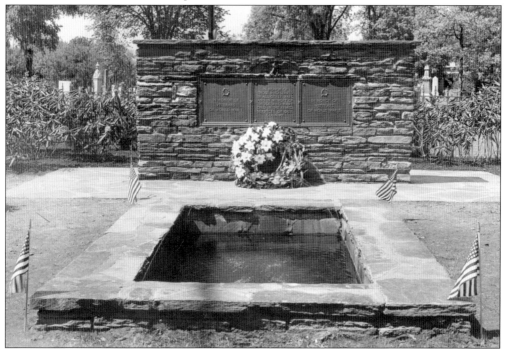

The War Memorial, the first major project taken on by the newly established Florence Civic & Business Association, was dedicated on Memorial Day 1947. It was built on the site of the former M.C. Howard building at the corner of Meadow and Park Streets.

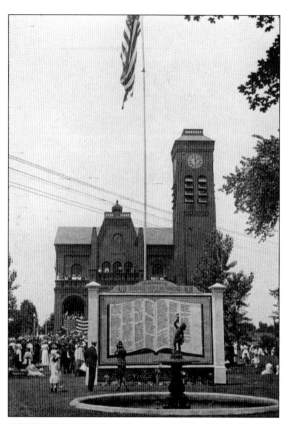

On July 1, 1918, Julius Maine and George Hayes, along with other citizens of Florence, wanted to have a Florence Roll of Honor erected along with a new flagpole in time for the Fourth of July celebrations.

In the span of three days, the monument was erected on Cosmian Park at a cost of $150. The flagpole was put in place, and a flag bearing 188 stars (honoring the Florence residents who were serving in World War I) was hung over Main Street. The names of each resident serving were inscribed in the Roll of Honor.

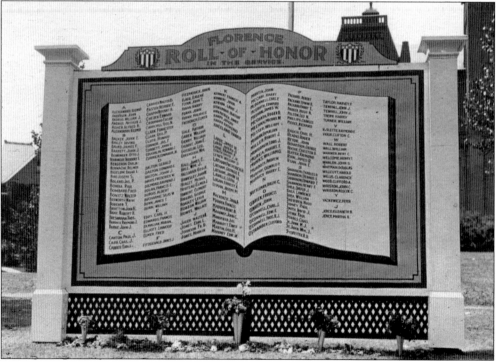

Eight
Frank Newhall Look Memorial Park

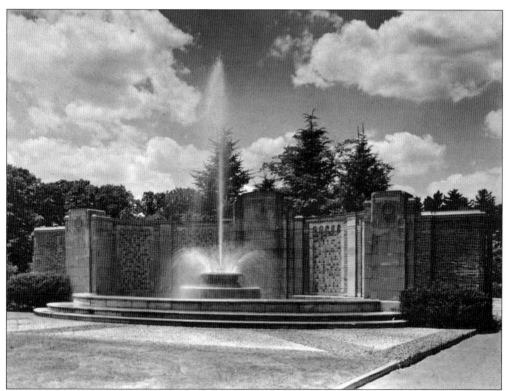

The fountain at the entryway of the Frank Newhall Look Memorial Park stands as a tribute to Mr. Look. Built in 1928, it once cast a jet of water 30 feet into the air and was illuminated at night by numerous colorful lights reflecting off the water. (Courtesy of Look Memorial Park.)

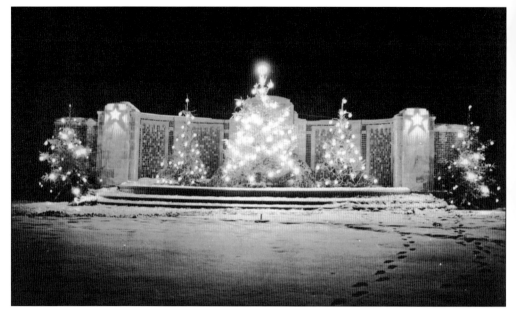

In the winter of 1933, the entrance to Look Park was a spectacular holiday scene, with five large Christmas trees all lit up with hundreds of lights glistening in the freshly fallen snow. (Courtesy of Look Memorial Park.)

This house was once the residence of John Warner and was originally located near what is now the Garden House in Look Park. In the late 1920s, it was moved about 300 feet south to make way for the entrance to the park. For years, it was used as living space for the park directors, but recently it has functioned as Look Park's office building. (Courtesy of Look Memorial Park.)

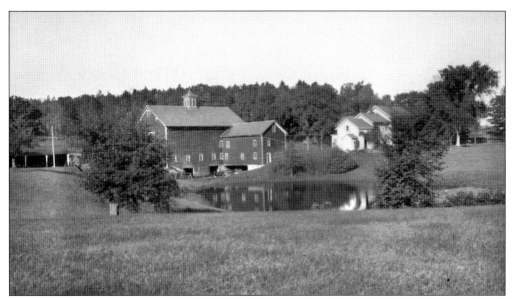

Here is an early view of the back of the Warner House with a large New England-style barn beside the pond. Much of the land at Look Park had previously served as a tobacco farm in the late 1800s. The pond later became known as the Rhododendron Pond, which can be seen as one drives into the park. (Courtesy of Look Memorial Park.)

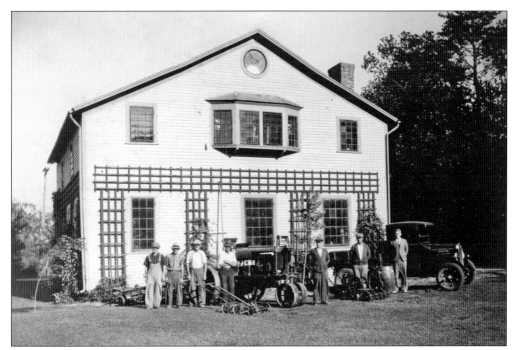

The park's maintenance crew posed for this picture in 1932. In the years before riding lawn mowers, one can only imagine the number of hours spent mowing over 100 acres of the park with the reel mowers that are displayed in this photograph. (Courtesy of Look Memorial Park.)

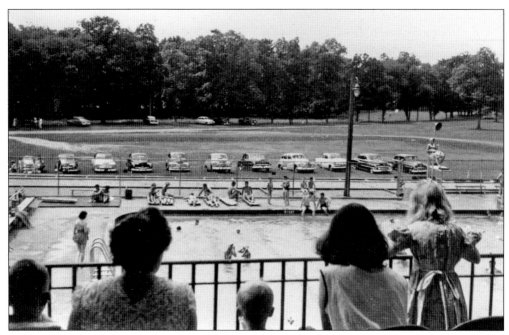

The swimming pool at Look Park was one of the city's most popular destinations during the hot summer months from the early 1930s until the turn of the century. When it was built, it was the largest outdoor pool in New England, accommodating over 25,000 visitors each summer season.

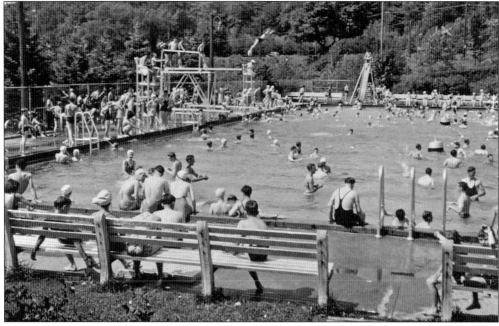

The aquatic slide on the far end of the pool was equipped with a water sprinkler to help speed up the ride. The pool also included several diving boards (including a high dive for the experienced swimmers) and ample seating surrounding the pool for those who just wanted to lounge in the sun. (Courtesy of Look Memorial Park.)

The Look Park pool opened on July 4, 1930, and by July 10, 1947, over half a million visitors had entered the pool house. These three lucky youngsters received certificates marking the milestone. They are Robert L. Hughes (left, visitor number 499,999), George Myers (center, visitor number 500,000), and Rosemary Boyle (visitor number 500,001). (Courtesy of Look Memorial Park.)

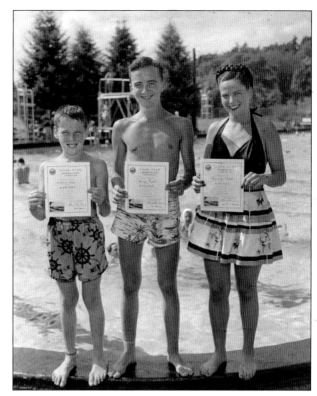

Very few people remember the Look Park band box that was located inside the swimming pool enclosure. Visitors could hear the popular music of the day and other forms of entertainment while their children enjoyed the cooling waters of the pool. (Courtesy of Look Memorial Park.)

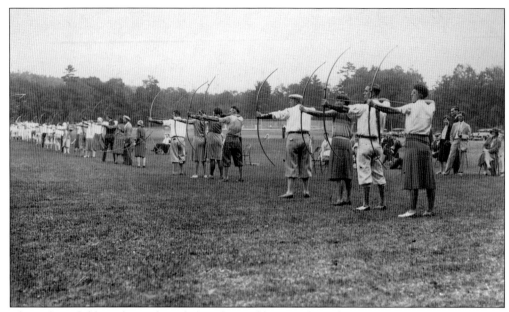

The archery field was located just below the pool house, where the tennis courts are today. Here, a group of several dozen men and women take aim during an archery contest. (Courtesy of Look Memorial Park.)

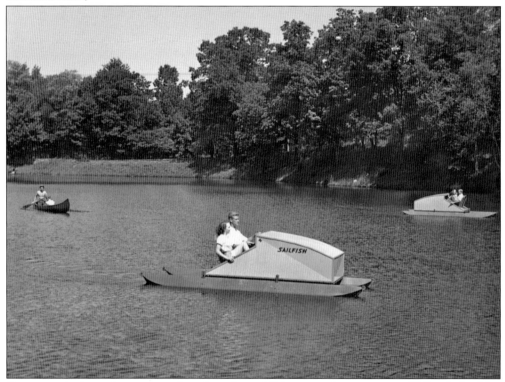

Young couples have always enjoyed a ride in the paddleboats on the picturesque Willow Lake. The boats shown here were in service for over 40 years, until they were replaced with the lightweight plastic peddle boats in the 1980s. (Courtesy of Look Memorial Park.)

The beloved Pancake Cabin was built around 1934. During the holidays, it was used by Santa and his elves as a workshop, where children could stop in for a visit and sip on some hot chocolate. Unfortunately, the cabin burned down in 1987. Very concerned children were relieved to find out that Santa was not in the cabin at the time of the blaze. By December of that year, Santa had set up his workshop at the Christenson Zoo. (Courtesy of Look Memorial Park.)

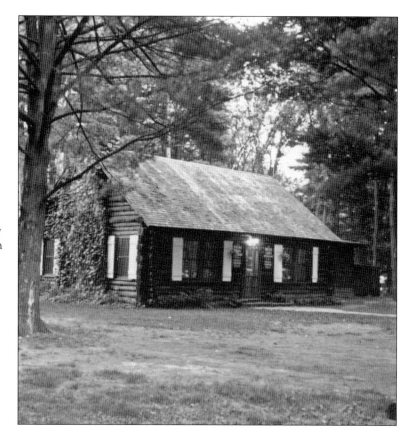

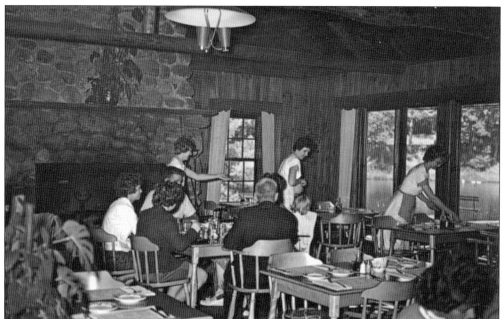

A family enjoys friendly service and the great affordable food inside the Pancake Cabin. Through the windows is a peaceful view of Willow Lake.

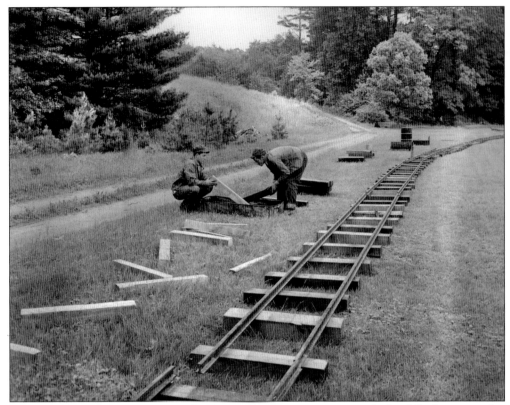

Here, two maintenance men are making repairs and improvements to the Look Park train tracks. The task would have involved spending days (or even weeks) taking apart the entire track system, removing the individual ties, and then dipping them in a vat of creosote before reinstalling them back under the rails. It must have been a dirty, exhausting, and backbreaking job. (Courtesy of Look Memorial Park.)

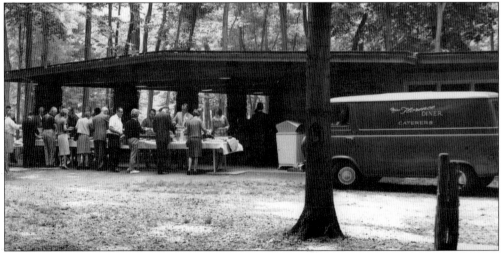

The pavilion has always been a popular spot for outdoor company events or birthday parties. In this photograph, the Florence Casket Company hosts a gathering catered by the Miss Florence Diner. (Courtesy of the Florence Casket Company.)

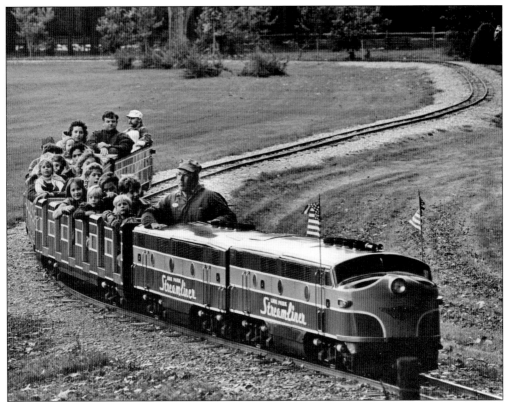

This was the last run of the original Look Park Streamliner in October 1985. It was being driven by the park's chief mechanic, engineer-for-a-day Richard Jaeske. The original Streamliner served the park for over 30 years, transporting over two million passengers during that time. A new train was purchased the following year and is still in service today. (Courtesy of the *Daily Hampshire Gazette*.)

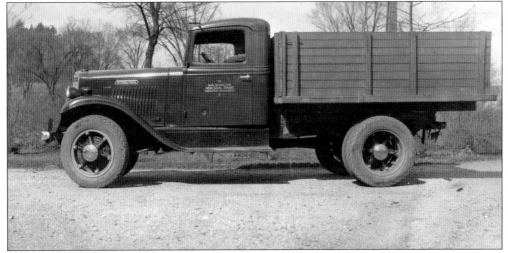

This duel-rear-wheel, flatbed maintenance truck was built by the International Harvester Truck Division in 1935. It was a powerful and versatile vehicle that served the park for many years. (Courtesy of Look Memorial Park.)

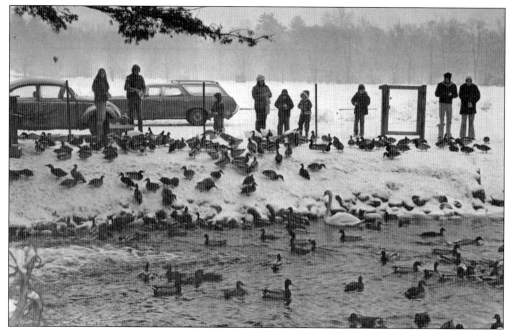

Generations of local residents have childhood memories of hopping into the car with their parents for a morning trip to the park to feed the ducks and swans leftover breads, cereals, and popcorn. This photograph was taken on a cold January morning in 1979. (Courtesy of the *Daily Hampshire Gazette*.)

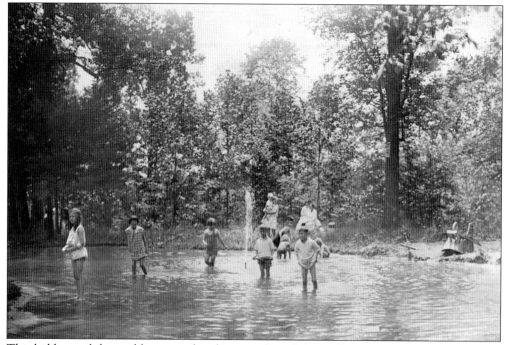

This kiddie pool, located between the playgrounds and the Mill River, provided a quieter and safer place for the smaller children to cool off away from often-crowded swimming pool. (Courtesy of Look Memorial Park.)

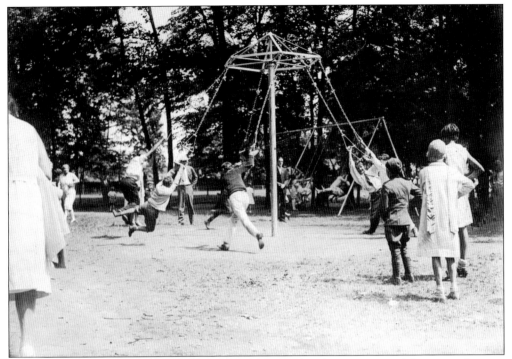

The faster they could run, the higher they would fly on this classic version of the carousel swing. Those who were lucky enough to hold on were launched into a dizzying orbit in which they had little time to calculate a soft landing to avoid tearing their pants or being plowed over by the kid behind them.

This is an interesting photograph of people playing shuffleboard (one of few games in which the skill of an 80 year old would be pitted against that of a 10-year-old child). The shuffleboards were busy all season, used by young and old. (Courtesy of Look Memorial Park.)

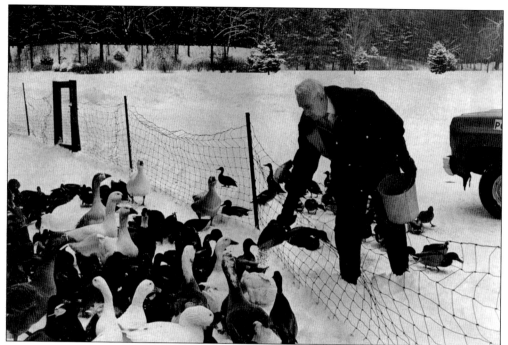

C. Victor "Vic" Christenson was employed at Look Park from 1940 until 1994 as parks security officer. In this photograph, taken on a snowy February afternoon in 1985, Christenson takes a few minutes to feed the Look Park ducks. In 1990, the zoo at Look Park was renamed the Christenson Zoo in honor of his years of service. (Courtesy of the *Daily Hampshire Gazette*.)

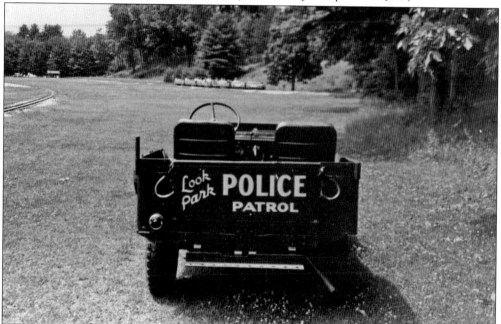

Vic Christenson drove this 1957 Jeep Willys DJ3A each day as he made his routine rounds throughout the park. The vehicle was retired in 1986 and was recently restored to its original condition by a private owner. It is sometimes seen in local parades. (Courtesy of Look Memorial Park.)

Nine
PAINTINGS AND POSTCARDS

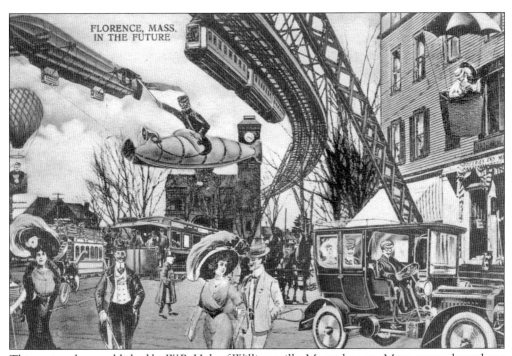

This postcard was published by W.B. Hale of Williamsville, Massachusetts. Many towns throughout the western part of the state had their own version of a postcard prophesying the future. An actual photograph was taken and then artistically painted in with a futuristic touch. This scene shows the intersection of Main and Maple Streets, looking north toward the Lilly Library and Cosmian Hall. (Courtesy of Jason A. Clark.)

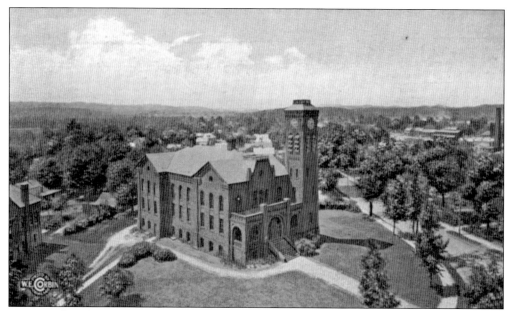

A postcard view taken by Walter E. Corbin and published by J.W. Bird shows the Cosmian Hall property from the top of the Florence Methodist Church steeple. At the time, the property was well groomed, with large shade trees along the street. (Courtesy of Jason A. Clark.)

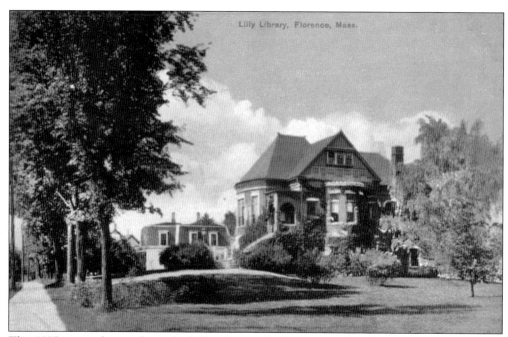

This 1905 postcard scene shows the Lilly Library, which, with its redbrick exterior and contrasting granite facade, is generally considered the architectural gem of Florence.

This postcard was published by J.W. Bird and shows the last trolley stop in Florence, at the corner of Park and Pine Streets. From here, the trolley would head back down Pine Street, take a left onto Maple Street, and follow Main Street before heading to downtown Northampton. (Courtesy of Jason A. Clark.)

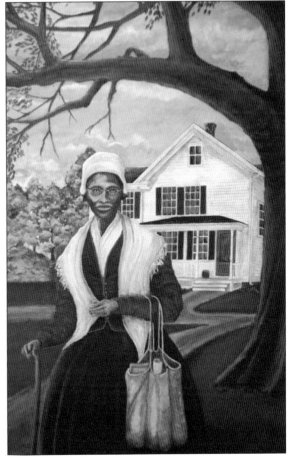

Sojourner Truth was a former slave who became a powerful orator and preacher. She arrived in Florence in 1843 to live, along with many others, in the Northampton Association of Education and Industry. Truth became a leading voice in the antislavery movement and eventually left Florence to travel throughout the United States delivering her message. (Painting by David Clark.)

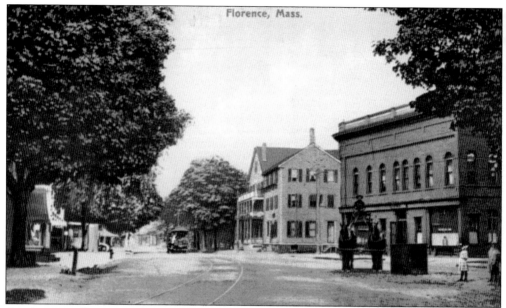

An electric trolley passes the Florence Hotel as it approaches Maple Street in this postcard view in the early 1900s. The Parsons Block can be seen to the right, behind the pair of horses stopping for a drink of water.

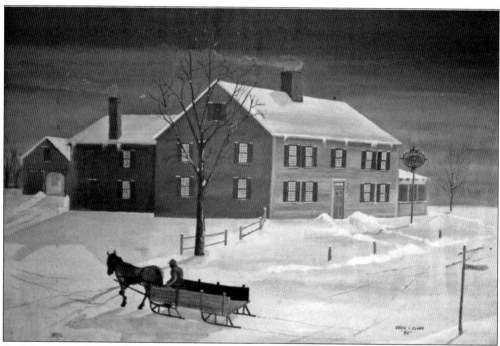

Paul Strong took over the tavern on the corner of North Maple and Main Streets in 1832 and operated the business until 1845. In the wintertime, local residents and travelers danced to live music at the popular and sometimes lively "sleighing parties" that lasted well into the cold, snowy nights. (Painting by Cecil I. Clark.)

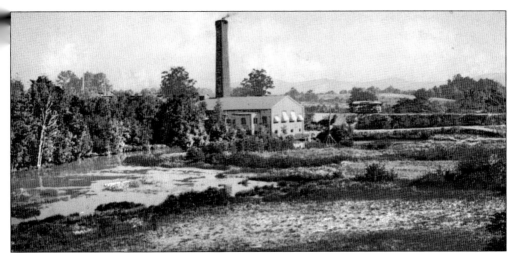

In 1893, when the electric trolleys were being introduced to Northampton and Florence, this power plant was built next to Locust Street. Located beside it were the trolley car barns. In the background of this photograph is a trolley car that has just left the barn and is traveling up the raised track to Florence. (Courtesy of Jason A. Clark.)

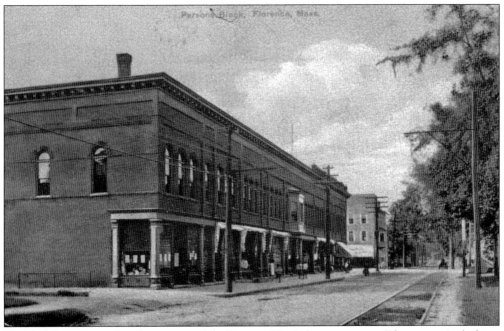

Herlihy's has operated at this corner of the Parsons Block for many years. The women's clothing store was established in 1927 by Alice B. Herlihy, who ran it with her husband, Edward Herlihy. Their daughter Alice took over the business in 1948, and it remained in the Herlihy family until it was sold to longtime employee Jean Ansanitis in the mid-1980s. Today, the business is owned by Linda Warburton.

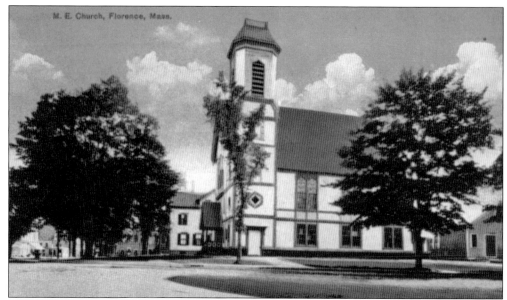

This angle of the Methodist church was taken from in front of the Lilly Library on Meadow Street. The steeple has since been removed, and the roads are now blacktop, but the view today is otherwise still quite similar. This postcard was printed in Germany and published by J.W. Bird. (Courtesy of Jason A. Clark.)

This building at 7 Main Street underwent extensive renovations in the late 1980s. It now has apartment spaces on the second and third floors, with several businesses located on the lower levels. Gordon Murphy and Tom Rockett operated a museum at this site for many years before relocating to North Elm Street in Northampton. (Painting by Jason A. Clark.)

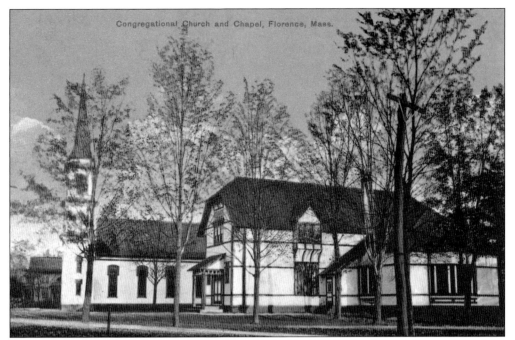

This postcard image, taken around 1910 and published by J.W. Bird, offers a different view of the Florence Congregational Church. The perspective is from the front of the Florence Grammar School, before the leaves filled in and obstructed the view. (Courtesy of Jason A. Clark.)

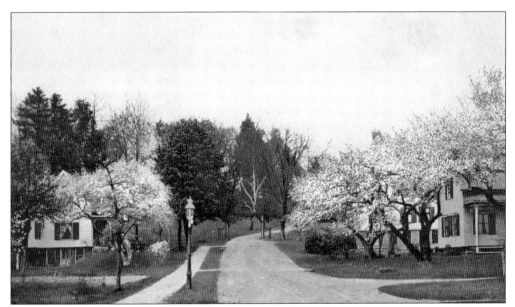

This postcard was printed in Germany for the Springfield News Company sometime between 1900 and 1910. It shows the mature fruit trees that line both sides of Fruit Street as it leads up to the gateway of the Learned Estate. (Courtesy of Jason A. Clark.)

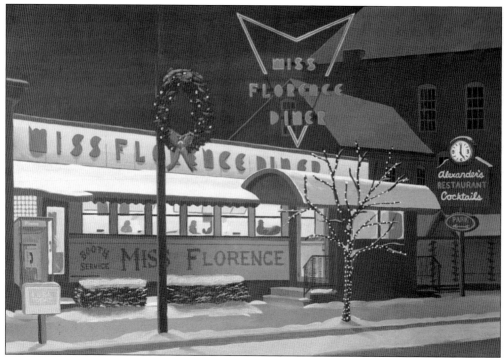

A freshly fallen snow during the holiday season provides a great opportunity for a quiet night out at the Miss Flo's Diner. (Painting by Jason A. Clark.)

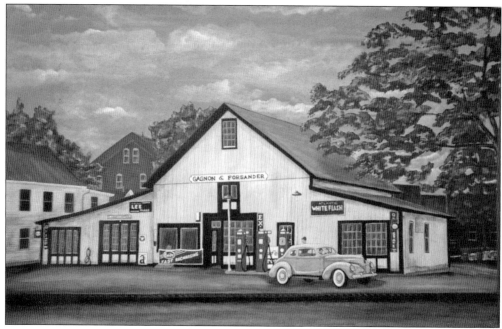

Here is a painting of the Gagnon & Forsander gas station and garage that was located on Depot Avenue. In the 1950s and 1960s, customers could drive in; "fill'er up;" and obtain any of the products and services of the time, including Atlantic Gas, Excide Batteries, Lee Tires, Quaker State Oil, and maps from Triple A. (Painting by David Clark.)

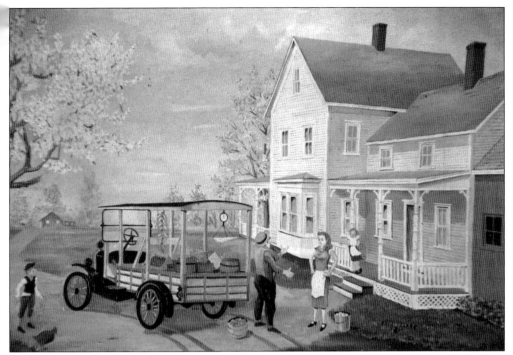

This painting depicts a house that was located at 25 Keyes Street in the early 1900s. The family is seen receiving a delivery of fruit and vegetables from a local grocer who made his home deliveries in his Model T open-air truck. Many years later, this home was moved to 70 Chestnut Street. (Painting by Cecil I. Clark.)

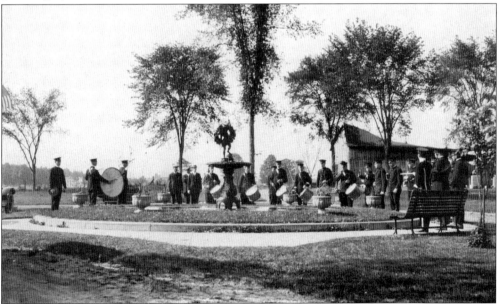

This photograph of a beautiful yet solemn day shows a procession of the Florence Marching Band encircling the lovely and tranquil fountain in Spring Grove Cemetery. It makes one respectfully remember that loved ones may rest here, and that you can only go "once around life," so do your best while you can and care for those around you.

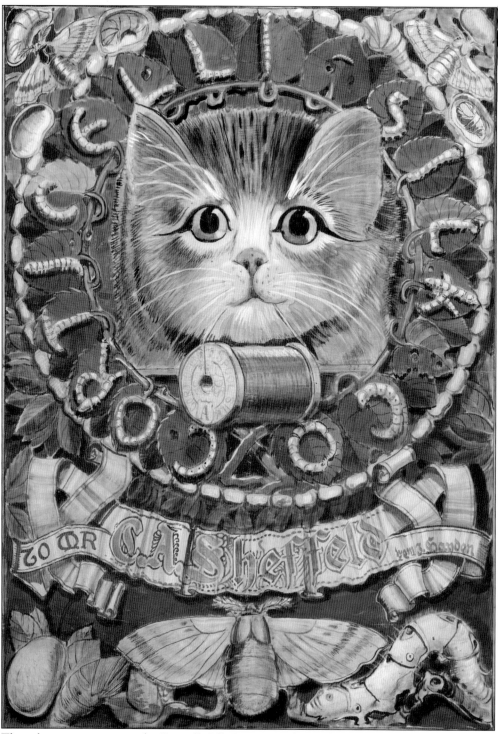

This oil painting re-creates the Coticelli Silk Company's famous kitten logo, which was originally designed by Charles Sheffeld. Recently acquired by the Florence Civic & Business Association, in memory of Cary Clark this painting is on permanent display in the Florence History Museum.

About the Organization

The Florence Civic & Business Association is located at 90 Park Street at the Florence Civic Center. The hardworking volunteers of the association help with many local annual events, such as the annual chicken barbecue every September or the Antique and Flea Market in early October. The Florence Luminary is held on the Saturday evening before Christmas Eve, and the Florence Mercantile committee sponsors one of the finest holiday light displays in the area.

Throughout the summer, the civic center hosts the Farmers Market on Wednesday afternoons and the Music on the Porch Summer Concert Series on Thursday evenings. The organization has sponsored many parades throughout the years and invites Santa to visit with the children on the Saturday after Thanksgiving.

The Florence History Museum is located in the front of the Florence Civic Center. For years, the residents of Florence have been donating old photographs and historical antiques. Many local photographers like Walter Corbin, the Howes brothers, and Knowlton Brothers captured images of Florence in its earliest days, and many of those images have been preserved within the Florence History Museum.

All of the author's royalties from the sale of this book will benefit the Florence Civic & Business Association and the continued renovations to the Florence Civic Center.

For more information about the Florence Civic & Business Association and its local events, please visit www.florencecivic.org.

Discover Thousands of Local History Books
Featuring Millions of Vintage Images

Arcadia Publishing, the leading local history publisher in the United States, is committed to making history accessible and meaningful through publishing books that celebrate and preserve the heritage of America's people and places.

Find more books like this at
www.arcadiapublishing.com

Search for your hometown history, your old stomping grounds, and even your favorite sports team.

Consistent with our mission to preserve history on a local level, this book was printed in South Carolina on American-made paper and manufactured entirely in the United States. Products carrying the accredited Forest Stewardship Council (FSC) label are printed on 100 percent FSC-certified paper.